John Lewis

Typography: design and practice

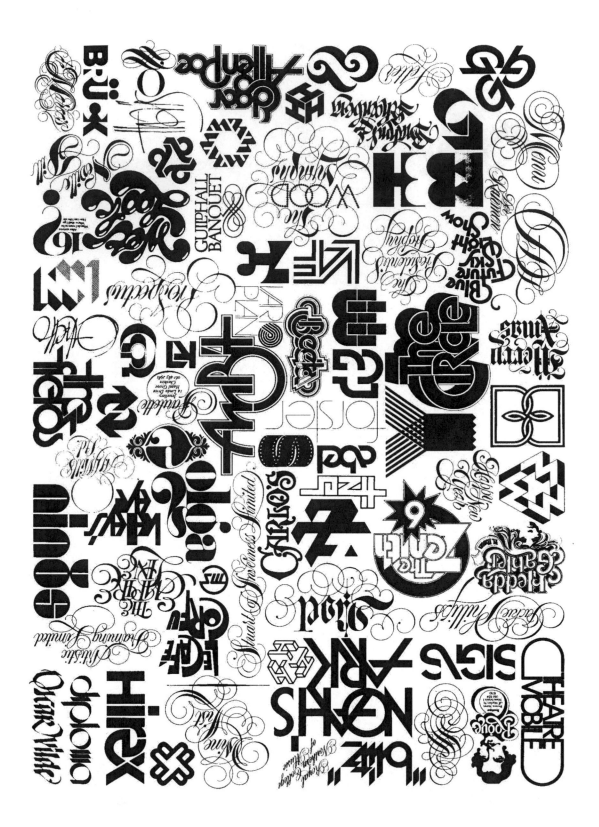

John Lewis

Typography: design and practice

CLASSIC EDITIONS

This edition digitally re-mastered and
published by JM Classic Editions © 2007
Original text © John Lewis 1977

ISBN 978-1-905217-45-8

Acknowledgements

I would like to thank Mr Albert Goldthorp of the Monotype Corporation for the trouble he has taken in preparing notes for me on filmsetting; Messrs Eyre and Spottiswoode for permission to reprint their short glossary of computer and photosetting terms; Messrs Conways Photosetting for their help over various technical points and for illustrations of typefaces and modigraphics; Messrs Penguin Books for permission to reprint Jan Tschichold's *Penguin Rules* and also for permission to reproduce Tschichold's designs for Shakespeare's *Sonnets* and a page from *Apollinaire: Selected Poems*.

For permission to reproduce illustrations, I wish to thank the Galerie der Spiegel, Cologne; Marlborough Fine Art (London) Ltd; the Museum of Modern Art, New York; Sidney Janis Gallery, New York; the Tate Gallery, London and Willy Verkauf and Arthur Nigli.

For the loan of illustrations, my thanks to Robert Brazil, Anthony Froshaug, Ian Hamilton Finlay, Tony Foster and James Sutton.

In addition I would like to thank Christopher Bradshaw, John Dreyfus, Ruari McLean, James Mosley and Richard Southall for their unstinted help, both in providing material and in answering my many questions.

Contents

List of illustrations

Introduction

This book has been developed from my *Typography: basic principles* which was first published in 1963. The first part of the book deals with the influences that have shaped the design of the printed page since the nineteenth century. This stands basically as it was before, but the various influences have been dealt with in greater depth.

As for the rest of the book, which is about the practicalities of the typographers' craft, so much has changed in the techniques of printing and typesetting over the last dozen years, that this has needed not only enlargement, but completely re-writing.

The main changes are the substitution of offset for letterpress printing and filmsetting for hot metal setting. In many ways, from the designer's point of view, these changes are for the worse! The apparent flexibility of offset printing, particularly for books where type and half-tone illustrations are integrated, and the use of film setting has resulted in a strait-jacket imposed by the high cost of corrections. The ease of correcting metal type or moving blocks about in a chase is not matched when using film. Vivid letterpress half-tones are too often replaced by flat and insipid offset reproductions. This is not the place to talk about the reproduction of pictures, but clearly the best typographic designs will be nullified by indifferent printing of not only the type but the pictures that may go with it.

The freedom of film setting and the constant use of Letraset *(et alia)* have freed the typographer from the precise restrictions of hot metal. This freedom has however deprived him of the firm structure that metal type imposes. One used to be taught that type was not made of rubber, so one's layouts had to be precise, one's cast-off exact. Today, with developments in photo-composition, types can be closed up or spread out and even the actual letters can be elongated or expanded as well. Such freedom can be an embarrassment.

All is not lost if typographers remember that their job is to communicate or at least to provide a channel of communication between author and reader. The manner in which they present their typographic message is the essence of this book.

auff der vart·Der thier vil geschossen wart·wan er
parg sich vor irē gesicht·Sie hūten sich gebutē mit
nicht·Also kamē sie in grosse not·Das sie wurden
geschossē tot·Do kam ein obel thier gerāt·Dē was
das geschos nicht wol bekant·Das trostet die clein
thierlein·Vnd sprach last eur vorcht sein·Jch sehe
weder man nach hunt·Der uns geschaden mag zu
der stunt·Sie woltē alsampt sicher wesen·Vil hau

Gothic textura typeface printed by A. Pfister at
Bamburg in 1462.

Ciceronē ibi offendisset:perrexit primū oés copias illi tradere : & sese ei summittere:ut
decens erat prætorium uiꝝ confulari:fed Cicerone non recipiente & in Italiā abeunte:co
gnita Pōpeii uoluntate:qui cū minime tēpus exposceret:eos qui i Italiā nauigabant:af
ficere suppliciis & i primis Ciceroni ipsi manus afferri cogitabat:priuati ipfum corripiēs
Ciceronē ex māifesto piculo liberauit:& cæteris faclcate abeūdi ꝓstitit.Arbitratus uero
Pōpeium magnū i Aegyptū aut Lybiam peruenisse:ad illum ire prexit cū oībus copiis:
data prius potestate abeundi iis q nō uoluntarie sequerentur.Catoni orā Lybiæ præter-
uecto fit obuiam Sextus Pōpeii filius minor natu:q mortē patris nunciauit:cuius mor
tem cum uniuersi grauiter ferrent:nec alium ducem sequi uellent : Cato detestatus ho-
minum persidiam:qui difficillimo tempore bonos desererent:principatum petiuit:& i
Cyrenē peruemens a Cyreneis receptus est:cum paucis ante diebus Labenū exclusisset.

Roman typeface printed by Nicolas Jenson in
Venice in 1468.

Ecco sencia præstolatióe sue patefacta, & itromessi, Se fece ad nui una
Matrona chrysaora cum gliochii atroci & nellaspecto prompta,uibran-
te cū la leuata sua spatha in mano & prælucéte.In medio della quale,una
corolla doro , & uno ramo di palmula itrauersato suspesa pendeua,Cum
brachii Herculei & da fatica,cum acto magnanimo, Cum il uétre tenue,
bucca picola,humeri robusti, Nel uolto cum demonstratione di non ter
rirse di qualunqua factione ardua & difficile,ma di feroce & giganteo ani
mo.Et il suo nomiatiuo era Euclelia, Et dixene nobile giouenette & obse
quiose uenerabilmente comitata.Il nome della prima Merimnasia, Del-

The old face type from *Hypneromachia Poliphilus*
printed by Aldus Manutius in Venice from types
cut by Francesco Griffo of Bologna in 1499.

1. The development of typographic design

In establishing a method of approach to design, the typographer would do well to look back in order to discover just how and why the page of books or pieces of ephemeral printing were so designed. No act of creation is built in a vacuum and anyone who cares about the look of the printed page would be most unwise if he ignored all that had gone before. This is not to say that any printed work should be a *pastiche* of earlier periods. A knowledge of the history of typography can however give a designer a point of departure for new creation, and can often give him salutary warning of what not to do.[1]

There has been since the very early days of printing a recurring conflict, first between the gothic black letter types of the fifteenth century German printers and the roman typefaces of their rivals in Venice. A similar conflict occurred again in the eighteenth century with the introduction of the engraved neo-classical roman letters. The old style letters were finally overwhelmed in the early years of the nineteenth century by the brash display typography that emanated from various English and American typefounders.

Robert Thorne at the Fann Street Foundry in Chiswell Street, London, issued the first of these display letters, a fat face in 1803. This was followed by Egyptians (Vincent Figgins 1815) and sans serifs (William Caslon IV, 1816). On these basic display forms of fat face, Egyptian and sans serif, hundreds of variants were produced. It must have been an exciting experience for the printers of the day, to have at their disposal this great variety of type material, after nearly three centuries of plain, often rather dull, roman letters. The appearance of bills and posters, labels, letterheads, tickets and all kinds of ephemeral printing changed completely, because of the variety of size, weight and form of the typefaces at the printer's disposal.

Yet book typography remained unchanged, with unchanged conventions of writing and reading. Books were still printed in the style and format that the Italians had established in the fifteenth century. They were however set in debased 'moderns' (the engraved style of letter introduced by Bodoni and Didot at the end of the eighteenth century).

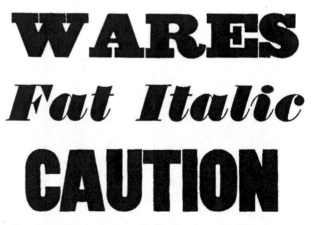

AaBbCcD Holding

A comparison of Neo-Classical and Old Face types.

WARES
Fat Italic
CAUTION

The three basic forms of display letter: Egyptian, Fat Face and Sans Serif.

1. See *The Typographic Arts* Two lectures by Stanley Morison. Cambridge and Harvard University Presses 1950. *Five Hundred Years of Printing* S. H. Steinberg. Penguin Books 1955. *Anatomy of Printing* The influence of art and history on its design. John Lewis. Faber, London and Watson Guptill, New York, 1972.

Manuale Tipografico: title-page from Bodoni's last type specimen book showing his Neo-Classical typefaces; printed in 1818 under the direction of his widow, five years after Bodoni's death.

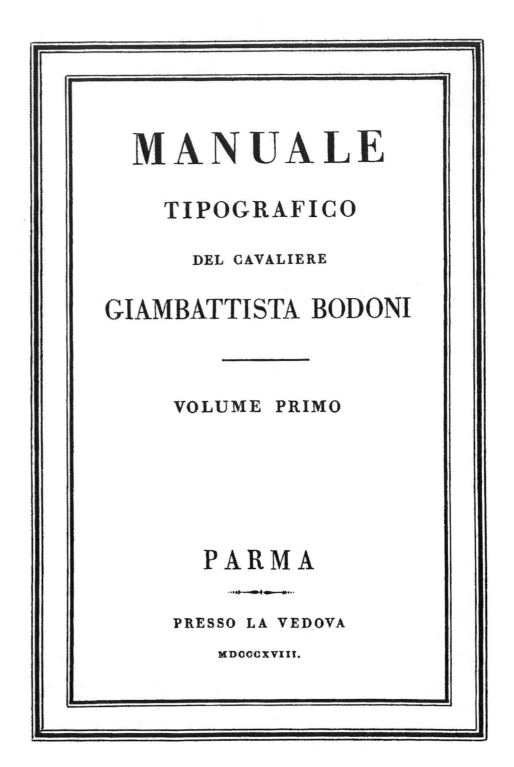

MANUALE

TIPOGRAFICO

DEL CAVALIERE

GIAMBATTISTA BODONI

———

VOLUME PRIMO

PARMA

PRESSO LA VEDOVA

MDCCCXVIII.

Display typography; mid-nineteenth century playbills showing a lively use of many different founts of display typefaces.

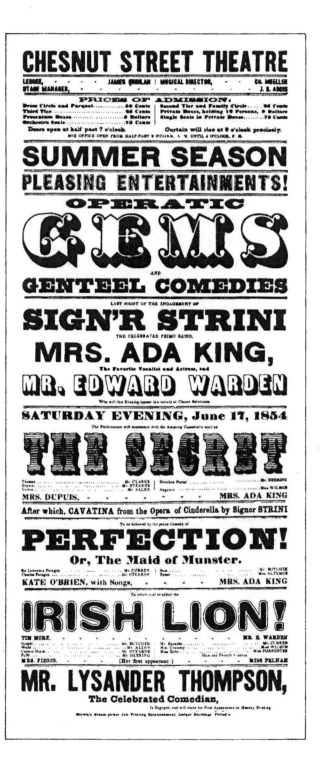

The title-page from J. McNeill Whistler's *The Gentle Art of Making Enemies*. Designed by Whistler in 1890.

THE GENTLE ART

OF

MAKING ENEMIES

AS PLEASINGLY EXEMPLIFIED
IN MANY INSTANCES, WHEREIN THE SERIOUS ONES
OF THIS EARTH, CAREFULLY EXASPERATED, HAVE
BEEN PRETTILY SPURRED ON TO UNSEEMLINESS
AND INDISCRETION, WHILE OVERCOME BY AN

UNDUE SENSE OF RIGHT

LONDON MCMLIII
WILLIAM HEINEMANN LTD.

The first revolt against the use of these attenuated 'modern' typefaces was made in the 1840's by the printer Charles Whittingham at the Chiswick Press, with a revival of Caslon's 'old face'. This was an isolated protest and the general standard of book typography and printing continued to decline.

WHISTLER AS A TYPOGRAPHER

The first revolution in the staid art of book design came from the painter Whistler. The part played in the development of typographic design by artists who were primarily painters or sculptors or even architects has never been fully acknowledged. They are a mixed gathering ranging from James McNeill Whistler to Peter Behrens and from Wyndham Lewis to Max Bill. It was in the 1870's that Whistler turned his attention to the design of his exhibition invitations and catalogues. His typographic layouts were remarkable for his use of white space, with type set in narrow measures. His margins were sometimes punctuated with shoulder notes decorated with variations of his Butterfly symbol. His chapter openings and title-pages were set in text sized capitals asymmetrically arranged, his copy was most carefully placed on the page.

In 1878 Whistler published the first of his booklets *Whistler v. Ruskin Art and Art Critics*. It was bound in simple, limp brown paper covers, printed in black. He used this style of binding for everything he published from then on, though for more substantial works such as *The Gentle Art of Making Enemies* which was published in 1890, the books were quarter bound with paper covered boards and yellow cloth backs, blocked in dark brown.

Whilst *The Gentle Art* was in production, Whistler and his publisher Heinemann would foregather at the Savoy for a belated breakfast. And there, on a deserted balcony overlooking the river Thames, they would discuss every little production detail. Whistler would sometimes spend hours positioning a single Butterfly.

Mr and Mrs Pennell in their biography[2] of Whistler describe how whilst *The Gentle Art* was being set: 'Whistler was constantly at the Ballantyne Press where the book was printed. He chose the type, he spaced

2. *The Life of James McNeill Whistler* E. R. & J. Pennell. Wm Heinemann, London and J. B. Lippincott and Company, Philadelphia, 1908.

the text, he placed the Butterflies, each of which he designed especially to convey a special meaning. . . . He designed the title-page: a design contrary to all established rules but with the charm, the balance, the harmony, the touch of personality he gave to everything. The cover was now in the inevitable brown, with a yellow back'.

The Gentle Art is much more than a typographic frolic. It is a beautifully designed book. Though Whistler was primarily a painter, he used words with the respect of someone who rejoiced in their use. He was the first modern typographer to show that typography is primarily a matter of placing words so that their sense becomes clearer, more pointed and more precise.

Technically, Whistler's typography is interesting for the way he made use of such rather indifferent typefaces as his commercial printers carried, and overcame their equally indifferent presswork. This was quite contrary to the views of William Morris and most of the succeeding private press printers, who were often obsessively concerned with type design and the materials on which they printed.

The manner in which Whistler made great play with white space and the way his copy was placed on the page with such precision was not to be seen again until the New Typography had reached its apogee in the years after the second world war. Whistler's consistent use of text size letters for his chapter openings is yet another factor that the post-Bauhaus typographers used.

No two men were less alike in their likes and dislikes and in their way of life than James McNeill Whistler and William Morris. Yet they had at least two things in common. One was a penetrating eye for detail; the other that they both wrote. That being so, it is not surprising that for a while both of them became interested in typography and particularly in the design of their own books. Yet no books could be less alike in their appearance than *The Gentle Art of Making Enemies* and the Kelmscott *Chaucer*.

Whistler, accepting all the limitations of contemporary commercial printers, brought a new approach to the design of books. Morris brought new standards to *how* books were printed.

Page from *The Gentle Art of Making Enemies,* showing the care with which Whistler placed his type matter.

OF MAKING ENEMIES 39

Final

W HY, my dear old Tom, I never *was* serious with you, even when you were among us. Indeed, I killed you quite, as who should say, without seriousness, " A rat! A rat!" you know, rather cursorily.

The World,
Jan. 15, 1879.

Chaff, Tom, as in your present state you are beginning to perceive, was your fate here, and doubtless will be throughout the eternity before you. With ages at your disposal, this truth will dimly dawn upon you; and as you look back upon this life, perchance many situations that you took *au sérieux* (art-critic, who knows? expounder of Velasquez, and what not) will explain themselves sadly—chaff! Go back !

THE WHITE HOUSE,
Jan. 10, 1879.

Double-spreads from *A Note by William Morris on his aims in founding the Kelmscott Press,* set in Golden type and printed in 1898. The pages without ornament represent Morris's teaching, the ones with borders his usual practice.

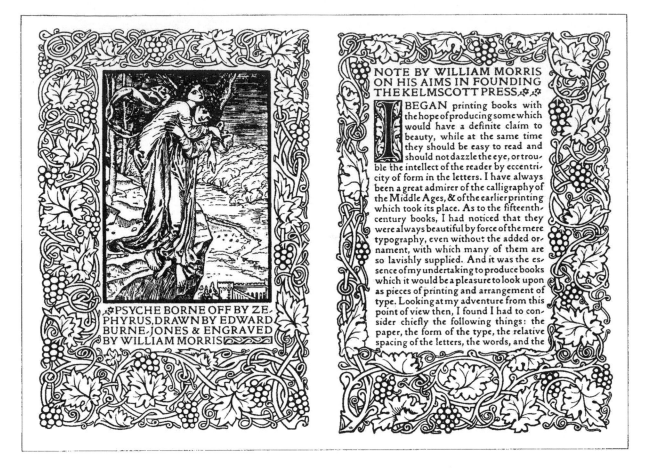

WILLIAM MORRIS AND THE KELMSCOTT PRESS

Morris, one of the first great figures in the modern movement of European design was a mediaevalist with very little sympathy for the Italian Renaissance or its art, and a qualified respect for its printing.

After a life time of practising – most successfully – a variety of arts and crafts including calligraphy, furniture decoration, wallpaper and textile design, (he even dabbled in typography), in 1891 Morris started the Kelmscott Press in a small cottage in the Upper Mall, Hammersmith.

Later he wrote: 'I began printing books with the hope of producing some which would have a definite claim to beauty, while at the same time they should be easy to read and should not dazzle the eye, or trouble the intellect of the reader by eccentricity of form in the

ledge of the technique of printing. These views were first expressed in an article by Mr. Walker in the catalogue of the exhibition of the Arts and Crafts Exhibition Society, held at the New Gallery in the autumn of 1888. As a result of many conversations, The House of the Wolfings was printed at the Chiswick Press at this time, with a special type modelled on an old Basel fount, unleaded, and with due regard to proportion in the margins. The title-page was also carefully arranged. In the following year The Roots of the Mountains was printed with the same type (except the lower case e), but with a differently proportioned page, & with shoulder-notes instead of headlines. This book was published in November, 1889, & its author declared it to be the best-looking book issued since the seventeenth century. Instead of large paper copies, which had been found unsatisfactory in the case of The House of the Wolfings, two hundred and fifty copies were printed on Whatman paper of the same size as the paper of the ordinary copies. A small stock of this paper remained over, and in order to dispose of it seventy-five copies of the translation of the Gunnlaug Saga, which first appeared in the Fortnightly Review of January, 1869, and afterwards in Three Northern Love Stories, were printed at the Chiswick Press. The type used was a black-letter copied from one of Caxton's founts, and the initials were left blank to be rubricated by hand. Three co-

10

pies were printed on vellum. This little book was not however finished until November, 1890.

Meanwhile William Morris had resolved to design a type of his own. Immediately after The Roots of the Mountains appeared, he set to work upon it, and in December, 1889, he asked Mr. Walker to go into partnership with him as a printer. This offer was declined by Mr. Walker; but, though not concerned with the financial side of the enterprise, he was virtually a partner in the Kelmscott Press from its first beginnings to its end, and no important step was taken without his advice & approval. Indeed, the original intention was to have the books set up in Hammersmith and printed at his office in Clifford's Inn.

It was at this time that William Morris began to collect the mediæval books of which he formed so fine a library in the next six years. He had made a small collection of such books years before, but had parted with most of them, to his great regret. He now bought with the definite purpose of studying the type & methods of the early printers. Among the first books so acquired was a copy of Leonard of Arezzo's History of Florence, printed at Venice by Jacobus Rubeus in 1476, in a Roman type very similar to that of Nicholas Jenson. Parts of this book and of Jenson's Pliny of 1476 were enlarged by photography in order to bring out more clearly the characteristics of the various letters; and having mastered both their virtues and

11

letters'. Morris had always been a great admirer of the calligraphy of the Middle Ages and of the early printing which took its place. He observed that fifteenth century books were always beautiful by force of the mere typography, even without any added ornament, with which many of them were so lavishly supplied. He set out to produce books which it would be a pleasure to look upon as pieces of printing and arrangement of type.

His observations on layout are revealing and to the point: 'I go as far as to say that any book in which the page is properly put upon the paper is tolerable to look at, however poor the type may be – always so long as there is no (bad) ornament which may spoil the whole thing. Any book in which the page is wrongly

A specimen page for the Doves Press bible, set in the Doves type which was also based on Nicolas Jenson's, but it was a very much cleaned up version, in fact a somewhat emasculated Jenson. This sheet was printed in 1901, though the bible was not completed until 1905.

Genesis 4 unto him two wives: the name of the one was Adah, & the name of the other Zillah. And Adah bare Jabal: he was the father of such as dwell in tents, and of such as have cattle. And his brother's name was Jubal: he was the father of all such as handle the harp & organ. And Zillah, she also bare Tubal-cain, an instructor of every artificer in brass and iron: and the sister of Tubal-cain was Naamah. And Lamech said unto his wives,

Adah and Zillah, Hear my voice;
Ye wives of Lamech, hearken unto my speech:
For I have slain a man to my wounding,
And a young man to my hurt.
If Cain shall be avenged sevenfold,
Truly Lamech seventy and sevenfold.

And Adam knew his wife again; and she bare a son, & called his name Seth: For God, said she, hath appointed me another seed instead of Abel, whom Cain slew. And to Seth, to him also there was born a son; and he called his name Enos; then began men to call upon the name of the Lord. ⟨ This is the book of the generations of Adam. In the day that God created man, in the likeness of God made he him; male and female created he them; and blessed them, and called their name Adam, in the day when they were created. And Adam lived an hundred and thirty years, and begat a son in his own likeness, after his image; and called his name Seth: and the days of Adam after he had begotten Seth were eight hundred years: and he begat sons and daughters: and all the days that Adam lived were nine hundred and thirty years: and he died. And Seth lived an hundred and five years, and begat Enos: and Seth lived after he begat Enos eight hundred and seven years, and begat sons and daughters: and all the days of Seth were nine hundred and twelve years: & he died. And Enos lived ninety years, and begat Cainan: & Enos lived after he begat Cainan eight hundred and fifteen years, and begat sons and daughters: and all the days of Enos were nine hundred and five years: and he died. And Cainan lived seventy years, and begat Mahalaleel: & Cainan lived after he begat Mahalaleel eight hundred and forty years, and begat sons & daughters: and all the days of Cainan were nine hundred and ten years: and he died. And Mahalaleel lived sixty and five years, and begat Jared: and Mahalaleel lived after he begat Jared eight hundred and thirty years, and begat sons and daughters: and all the days of Mahalaleel were eight hundred ninety and five years: and he died. And Jared lived an hundred sixty and two years, and he begat Enoch: and Jared lived after he begat Enoch eight hundred years, and begat sons and daughters: and all the days of Jared were nine hundred sixty and two years: and he died. And Enoch lived sixty and five years, and begat Methuselah: and Enoch walked with God after he begat Methuselah three hundred years, and begat sons and daughters: and all the days of Enoch were

4

Kelmscott Press typography: a page from the *Biblia Innocentium,* set in Morris's Golden type, based on the fifteenth century model of Jenson. Designed and decorated by William Morris in 1892.

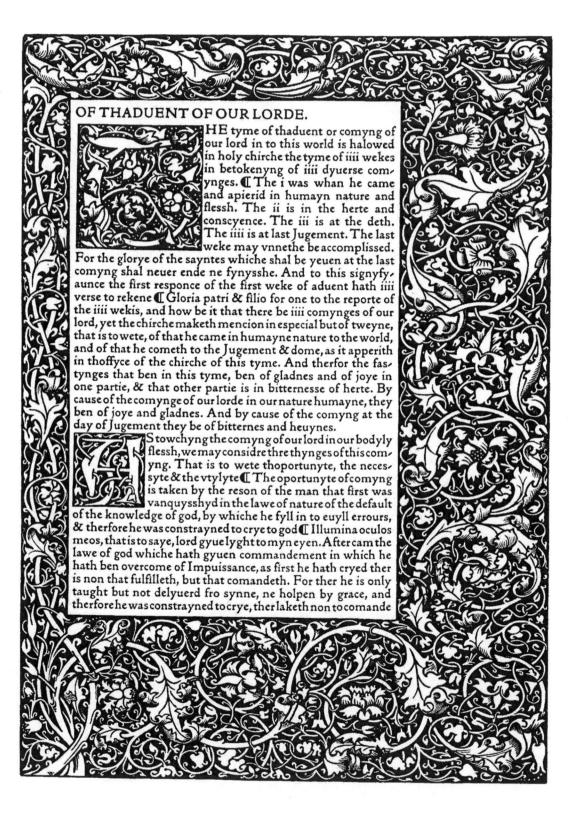

This is the Golden type.

This is the Troy type.

This is the Chaucer type.

The three typefaces designed by William Morris, the Golden type designed in 1890, the others in 1893.

set on the paper, is intolerable to look at however good the type and ornaments may be.' Books he maintained, were completely satisfying even if their only ornament was the necessary and essential beauty which arose out of the fitness of a piece of craftsmanship for the use for which it was made.

His Kelmscott books, cluttered up with ornament as they were, did not quite bear out this precept. They are curiously archaic and essentially pre-Renaissance in conception. His use of type, however, is of interest. Morris wanted a close textured, rich dark page.

In an attempt to get away from the grey roman letter, Morris began by re-drawing Jenson's beautiful typeface, which was first used in Venice in 1468. He said that he wanted a letter that was pure in form, and solid without the thinning and thickening of the line which he thought was one of the essential faults of the modern type, and which made it difficult to read. He also wanted a type that was not compressed laterally. His conclusion was that Jenson's type was the only source for a roman lower case letter.

He did not copy it servilely; in fact his roman type, especially in the lower case has a slightly gothic look about it. This still did not satisfy him for he felt more and more that for his books he must have a 'gothic' (black letter) rather than a roman fount. He set himself the task of redeeming the gothic character from the charge of unreadability, which is commonly held against it. He did eventually design a black letter as readable as any roman.

All Morris's leanings were towards a revival of pre-Renaissance letter forms; his real interest in fine books was confined to incunabula; that is to those printed before 1500. His declared preference obviously was for those set in black letter. Emery Walker, his adviser at the Kelmscott Press and one of the partners in an equally famous private press, the Doves Press had very different ideas, for he was a devoted admirer of Renaissance printing. All the subsequent private presses followed the lead of the Doves in their admiration for the fifteenth century Italian printers and their roman typefaces.

Morris alone, amongst the typographers of this printing revival, was convinced that the answers to problems

of type design and other design problems lay in the study of the work of the Middle Ages. His great interest in the value of hand-made things, his obsession with materials, his peerless quality as a decorator and designer of fabrics and wallpapers, all this is admitted handsomely by his historians. The effect of his work on the Deutscher Werkbund, on Gropius and on the Bauhaus is equally acknowledged. The one thing that has been glossed over is his typography. Though he has been lauded for his printing standards, his typographic design has nearly always been dismissed as mock-mediaevalism. Yet his search for a more vital page than he could get from the grey roman types led him first to his dark version of the evenly weighted Jenson types and then to his very readable black letters.

The move from a black letter to a bold grotesque or sans serif is not so far. There is much confusion about the nomenclature of sans serif typesfaces. Various typefounders have called these faces grotesques, sans surryphs (san serifs) and gothics, which might be a clue to their origins, for the typefounders were satisfying a commercial and social demand for a black letter some seven or eight decades before William Morris produced his black letter, a true gothic typeface. The bold grotesque is much nearer to Morris's black letter than it is to the old style roman typeface. I do not think that this is too far-fetched.

I would claim more for Morris (speaking purely on typographic grounds) than a mere negative rejection of Renaissance ideals and Renaissance typography. He was preparing the ground for *Die Neue Typographie*.

In the late nineteenth century in England, there were two art movements in some rivalry with each other. The first, the Arts and Crafts Movement, was inspired by Morris's views of Guild Socialism and on the need to reject the machine age of the Industrial Revolution. The second was Art Nouveau.

ART NOUVEAU TYPOGRAPHY

The art nouveau movement was a key element in the development both of modern architecture and the new typography. Art nouveau at first appeared to be just a decorative movement, with origins in mediaeval illumination, gothic stained glass and Oriental art. The curved

St Augustine required high stand

The comparison between a Gothic Black Letter and a Bold Grotesque.

25

Double-spread from *A Defence of the Revival of Printing* written and designed by Charles Ricketts in 1899. Set in Vale type, designed by Ricketts and based, as was Morris's Golden type on Jenson's typeface.

to suit the exigencies of the new material, i.e., type, and it is the duty of the modern student to note how this or that element was lost in the excitement of discovery, or else merely over-looked; to compare, reason and recast, that his type may fulfil the requirements and benefit by the conditions of his proper medium, and so become type—type only.

In the history of the finer Italian printers we may almost date certain founts by the still surviving traces of penmanship, that Jenson will discard for practical reasons. With Sweynheym and Pannartz, Hahn, and Spira, the body of the "h" curves in gracefully, also the final curve to the "m" and "n"; these traits, pretty in themselves, are apt to clog in printing and the "h" to resemble a "b." With Jenson, revising the work of Spira, these letters "h," "n," "m," become what they are to-day. This, and greater system or consistency in the shaping of serifs and the punctuation, has placed Jenson in the front place as a designer

6

of type, though in the shape and intention of separate letters Spira is often his superior. Again the shaping of the top serifs to the "u" causes some perplexity to each printer in turn. Let me add that among old printers this problem remains unsolved. In the Kelmscott golden type the serifs to this letter are diagonal, thus avoiding the aspect of an "n" upside down, & following the trend of the older scribes. To me this course reduces the apparent height of an important letter and produces a gap; moreover the skilful designer may differentiate his "u" from a reversed "n" by the termination of the last stroke and so cut through the hesitations of the great printers who frequently shape the separate serifs differently.

System, conformity, are the secrets of fine type making. Sleight of hand in manuscript may disguise poorness of form and detail. Once in type each fault tells and is repeated over and over again; your stops, dots, accents must no longer

7

line so typical of the movement was one of the easiest forms for the blacksmith and the metal worker to shape. One of the supreme exponents of art nouveau design was the Glasgow architect, Charles Rennie Mackintosh, whose sinuous lines and use of white space was soon reflected in the book designs of Talwin Morris, typographer to Blackie's, the Glasgow publishers, and in the work of the Group of Four, which consisted of the two Macdonald sisters, Herbert McNair and Mackintosh.

The most significant English art nouveau book designer was Charles Ricketts (1866–1930), painter, stage designer, wood engraver, magazine and private press publisher. In partnership with his friend Charles

Tess of the d'Urbervilles: title-page designed by Charles Ricketts in 1901.

TESS
OF THE D'URBERVILLES

A PURE WOMAN

FAITHFULLY PRESENTED BY

THOMAS HARDY

IN THREE VOLUMES

VOL. II

'. . . Poor wounded name! My bosom as a bed
Shall lodge thee.'—W. SHAKSPEARE.

O. M.

JAMES R. OSGOOD
McILVAINE & CO

*ALL RIGHTS
RESERVED*

Art Nouveau book design: double-spread from
Goblin Market by Christina Rossetti, designed and
illustrated by Laurence Housman in 1893.

Shannon, Ricketts published the first number of their magazine *The Dial*, in 1889; in the next year he designed his first books for commercial publishers, amongst which were Thomas Hardy's *Tess of the d'Urbervilles* for Osgood McIlvaine and Oscar Wilde's *The Picture of Dorian Gray* for Warde Locke.

It was Wilde who influenced Ricketts and actually introduced him to his first patrons.[3] It had been Whistler who had drawn Wilde's attention to book design. Whistler's influence can be seen in the *Tess* title-page, but Ricketts had not reached the assurance or the skill of his master. However, within half a dozen years, he and Shannon launched the Vale Press and

3. *The Art Nouveau Book in Britain* John Russell Taylor. Methuen & Co, London, 1966.

produced some of the most attractive and readable of all the press books.

Ricketts as a typographer absorbed many influences apart from Whistler; he admired the early work of William Morris, though not the gothic style of the Kelmscott books. Ultimately he based the design of his books on the immaculate pages of the sixteenth century Italian printer typefounder Aldus Manutius.

Charles Ricketts was much more like the modern typographer than any of his private press contemporaries. He never had his own printing press but worked with ordinary commercial printing houses such as the Ballantyne Press, exacting the most rigorous standards from them. We owe much to Ricketts who was one of the first to blaze the trail for working typographers of today.

On the Continent, and particularly in Austria and also Germany, the art nouveau movement was given some impetus when, in 1900, Mackintosh and the others in the Group of Four exhibited their work in Munich and later in Vienna. Peter Behrens, a Munich architect, was one of those most strongly influenced. In 1901, Behrens turned his attention to the graphic arts and designed a typeface, strongly art nouveau in character. This was for Rudhard'sche Giesserei (later to become the famous Klingspor Typefoundry). Behrens in his turn had a marked influence on Gropius, the first principal of the Bauhaus.

In 1893, the Belgian painter and architect, Henri van de Velde, as a relaxation after a mental breakdown turned to graphic design and drew some initials for *Van Nu En Straks*, which have all the sinuous qualities that we associate with art nouveau. In the following year Van de Velde wrote an essay on the need for '*Un art nouveau,*' set in typefaces based on those William Morris had designed for the Kelmscott Press, which, so Behrens wrote: 'Surpass all the older Roman characters in decorative beauty'. Morris's typography, the antithesis of British art nouveau, was surprizingly close to the work of Continental art nouveau designers.

There is a very marked difference between the British art nouveau and Germany's *Jugendstil* (as their art nouveau movement came to be called). Illustrators like

JUGEND

Die zehnte Muse

JOHANNES

Art nouveau typefaces: Eckmann-Schrift designed
by Otto Eckmann in 1900.

Beardsley and typographic designers such as Talwin
Morris and Charles Ricketts made much use of white
space, as did Mackintosh in his open white rooms. The
Jugendstil still has the same sinuous curves, but the
designs of artists like Mucha are more clotted, more
claustrophobic and the letterforms and typefaces are
heavier, for they were based on gothic scripts, rather
than the roman letter.

The title *Jugendstil* was derived from the name of a new
review, *Jugend* which was first published in Munich in
1896. One of the young designers who worked for this
magazine was Otto Eckmann. He was a follower of
Beardsley, but was also interested in inventing new letter
forms, which he used for book jackets. In 1898 he
produced some striking letters, half uncial in character,
for the cover of Hermann Sudermann's tragedy *Johannes.*
Karl Klingspor, the head of Rudhard'sche Giesserei, on
seeing some of Eckmann's book covers and title-page
designs, commissioned him to design a new display
typeface. The result was *Eckmann-Schrift,* as unlike the
British concept of art nouveau as could be, but it falls
right in the middle of *Jugendstil* and is much nearer to
a gothic letter than to a roman one.

Rudolf Koch, Walter Tiemann and E. R. Weiss were
other successful German designers of typefaces in this
genre. The art nouveau typefaces which were designed
and produced in England and in the United States, and
all apparently anonymous, tended to be lighter and
spindlier than their German counterparts. But after all,
as is now clear, their origins lay with the roman letter,
however Orientalised or broken-backed they became.

Art nouveau, which for so long, was regarded as a
wayward even perverted decorative movement, has come
to be recognised as being an important stage in
twentieth-century design. The effect on printing of the
movement has been lasting. The fact that followers of
William Morris and the Arts and Crafts Movement soon

Art nouveau book design: cover to a cheap edition of Shakespeare by Talwin Morris. 1904.

English art nouveau typefaces. c. 1890.

shied away from art nouveau is now of little significance.

Viewed through the perspective of time, there seems much that is stylistically similar in the work of both these movements. They were both intermediate movements, bridging the gap between the transitional ideas of the nineteenth century and the modern movement. The Arts and Crafts members had their hand-made sandals more firmly on the ground but art nouveau was more than a fleeting thing, of limited appeal to the aesthetes who accepted 'art for art's sake'.

Art nouveau and the Arts and Crafts Movement between them made possible the work of the Bauhaus. Art nouveau bequeathed a feeling of space and asymmetry – two of the exhilarating qualities to be found in Bauhaus design and particularly in Bauhaus typography. The Arts and Crafts handed down to the Bauhaus the value to the designer, of solving his problem by handling the material himself.

In English typography, the art nouveau movement helped to start a new free style, in complete reaction to the centred style, used until then by every compositor. (There were few designers of print then.)

The purity and spaciousness of art nouveau were soon debased by an accumulation of printers' ornament. Art nouveau motifs lingered on in the design of printing until the 1920's. Some of the display typefaces produced at this time, oddly shaped though they are, have a certain vitality which may justify their periodic revival.

Art nouveau motifs appeared in mass produced furniture for another decade, but were obliterated by the Jazz age, with a zig-zag line that derived (many times removed) from the first of the Cubist paintings.

It was superseded more by the 'modernistic' movement of Art Deco so painfully revealed in the design of cheapjack electric light fittings, and in the 'commercial art' of the 1920's, than by the geometry and the mechanistic logic of the Bauhaus, for after all it was one of the movements from which the Bauhaus developed.

In England, after Morris's death, the whole trend of the typography of the private presses that succeeded Kelmscott was to a revival of Renaissance typography.

Rejecting Morris's mediaevalism, the private presses based their ideas on the work of the Venetian printers

THE RED LETTER SHAKESPEARE

JAPANESE Ornaments

Orpington & District *
* Industrial Exhibition,

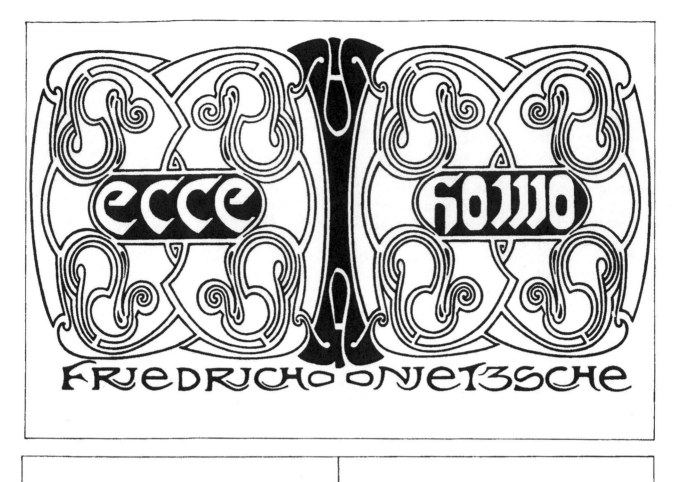

ecce homo

FRIEDRICH ONIETZSCHE

DAS·BINDEN DES·HAARES AUS·THE·SECRET·ROSE VON·W·B·YEATS·AUTOR ISIRTE·ÜBERSETZUNG·VON ARIE·DAUTHENDEY.

322

Die Krieger der jungen und weisen Königin Deerira und des alten und thörichten Königs Lua hatten vom Berge Gulben bis zur See eine Reihe von Feuern angezündet und Wächter an jedes Feuer gesetzt. Sie hatten ein großes Haus für Zusammenkünfte gebaut, die Umzäunungen mit Häuten bedeckt und kleinere Häuser zum Schlafen, und hatten rings um das Ganze einen tiefen Graben gezogen. Jetzt saßen sie im großen Haus und erwarteten einen Angriff von den Stämmen des Volkes vom Sacke, die von Süden kommen sollten, und sie lauschten dem Barden Aodh, der ihnen eine Geschichte von den Kriegen Hebers und Heremons sagte. Die Erzählung war auf dünne Holzstreifen geschrieben, welche der Barde vor sich hielt wie einen Fächer. Hie und da ergriff er sie an der kupfernen Angel und legte sie weg um eine fünfsaitige Lyra vom Fußboden aufzunehmen, zu der er hastig mit heftigen Bewegungen einen der vielen Gesänge sang, welche in den tieferen Teil der Erzählung eingeflochten waren. Trotzdem der Barde berühmt war und Anspruch auf Abstammung von jenen Barden Hebers und Heremons machte, um welche die Stämme beim Entstehen der Welt Würfel warfen, hörte der alte thörichte König nicht zu, sondern lehnte seinen Kopf auf das mittlere Kissen und schnarchte tuchtig in einem weinschweren Schlaf. Aber die junge Königin saß unter ihren Frauen still und gerade wie eine weiße Kerze und horchte, als wenn es keine andere Erzählung auf der Welt gäbe, als die von Aodh, während das Entzücken seiner traumvollen Stimme in ihren Ohren war und das Entzücken seiner traumfernen Geschichte in ihrem

323

and typefounders, and their successors, Garamond in Paris and Caslon in England. They reformed their ideas, and so their printing on Renaissance ideals. The typographers of this movement would have no truck with the neo-classical typefaces of Bodoni and Didot; it was the old style or nothing – and as for sans serifs . . . or the Bauhaus . . .!

Morris's influence was absorbed by the German architect Hermann Muthesius who from 1896–1903, worked in England doing research on English housing. In 1908 Muthesius's *Das englische haus* was published in Berlin. In this book Muthesius showed the designs of various British architects including Charles Rennie Mackintosh and C. R. A. Voysey. Much impressed by the work of the Arts and Crafts Movement, he inspired the foundation of the Deutscher Werkbund, mainly as a result of a public lecture, where he flayed the German industrialists for their backward looking tendencies.

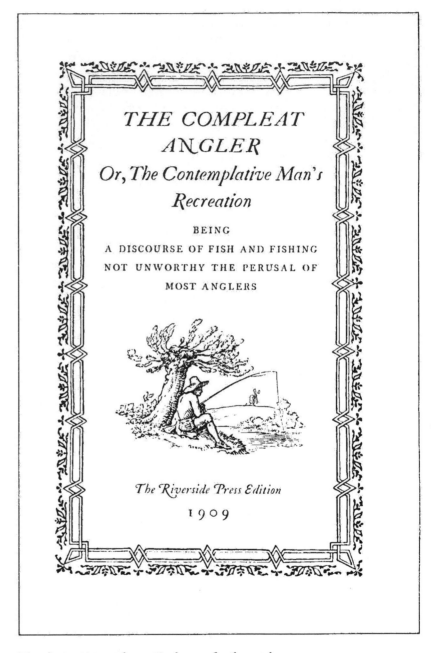

The decorative and practical use of rules and fleurons: *The Compleat Angler* title-page designed by Bruce Rogers in 1909.

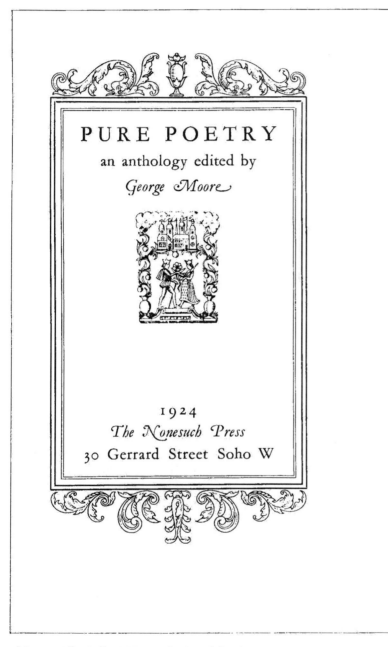

Title-page from *Pure Poetry* designed by Francis
Meynell for the Nonesuch Press in 1924, who
follows some fifteen years after Bruce Rogers had
established this particular style.

The Deutscher Werkbund was the German equivalent and successor to the English Arts and Crafts Movement. One of the youngest of the Werkbund leaders was the architect Walter Gropius, who, in 1914 at the suggestion of the famous Belgian architect Henri van de Velde, was appointed the first principal of the Bauhaus at Weimar, under the patronage of the Duke of Saxe-Weimar. This combined art and technological school was intended by Gropius to be 'a consulting centre for industry and the trades.'

The war delayed its opening until 1919. Before the war Gropius had established himself as a 'revolutionary' architect. His work, and so his teaching, was based on a mixture of the Arts and Crafts Movements, German Functionalism (Sachlichkeit) and Expressionism. The story of the Bauhaus and its move to Dessau in 1925, Gropius's departure in 1928 and its final closure by the Nazis in the 1930's is outside our province.

THE BAUHAUS TYPOGRAPHY WORKSHOP

The work of the Bauhaus typography workshop is very much our business.[4] When the Bauhaus was founded, the European art world was in turmoil, with new movements springing up everywhere. The most potent of these movements was Cubism, originating in Paris with the work of Picasso, Juan Gris and Braque. But there was also Futurism in Italy, Constructivism (the work of Mondrian and the Stijl group) in Holland, Suprematism in Russia, both Expressionism and Dadaism in Germany and Vorticism in England. All these movements had varying effects on the work of the Bauhaus for, though it was founded at least in part as a result of Morris's teaching, the Bauhaus was primarily a technological school. Most of the English art schools were also founded as a result of Morris's teaching and the work of the Arts and Crafts movement. Many of these schools were soon drifting in a world of academic, craft-based teaching, instead of attempting, as the Bauhaus did, to come to terms with the new age of technology with its great need for designers.

The German Expressionist movement was a reaction against the visual realism of Impressionism. Its inherent characteristics were the expression of both violence and

4. *Bauhaus: 1919–1928* Ed. Herbert Bayer, Walter Gropius and Ise Gropius. Museum of Modern Art, New York, 1938.

sentimentality. The most characteristic features of the paintings were bright colours and heavy outlines. Expressionism certainly had a lasting influence on the graphic arts, but it could not be said to have had much effect on typographic design.

One might have expected that a movement like Vorticism would have had some effect on the design schools. In fact so little graphic design was taught in English or American art schools until the 1930's, that the Vorticist journal *Blast* completely misfired on that particular target. Yet Vorticism still has a message today.

The ground was prepared for Vorticism by the visit to London in 1913–14 of Marinetti, the Futurist leader. Futurism became the fashion for everything from bathing dresses to lampshades. The Vorticists reacted against this with some violence.

Vorticism was an anti-Romantic movement. The leaders, particularly Wyndham Lewis, were absorbed with the idea of blasting all out-moded elements of English art out of existence and replacing this artistic junkyard with Vorticism – 'a new living abstraction'. They even called Marinetti and the Italian Futurists 'romantic and sentimental'.

In the first number of *Blast*, the opening manifesto was a typographic extravaganza, asymmetrical, and with big, bold badly printed capital letters blazing across the page. This apparently impressed the Russian typographer Lazar Lissitzky. The *Blast* typography, clumsy though it may seem to be today, looked most revolutionary in 1914.

Of the new movements, Cubism, Suprematism, Constructivism, de Stijl and Dadaism had most effect on the Bauhaus. The origin of Cubism can be seen in the work of the Post-Impressionists, for the pointillism of Seurat, the colour of Gauguin and Van Gogh, and Cézanne's obsession with form and structure had together produced an analytical approach to painting that made possible the final dissection of the visible world by the Cubists, who in their turn broke down the visual appearance of everyday objects into paintings that were quite beyond conventional observation. For example, by showing more than one view at the same time of an object they showed that the perspective vision of

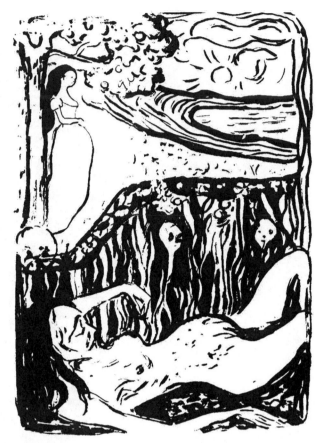

Expressionism: *Tod und Leben*. Lithograph by Edvard Munch. 1897.

37

SCRABrrRrrNNG: Futurist poster: *Les mots en liberté futuristes* by F. T. Marinetti 1919.

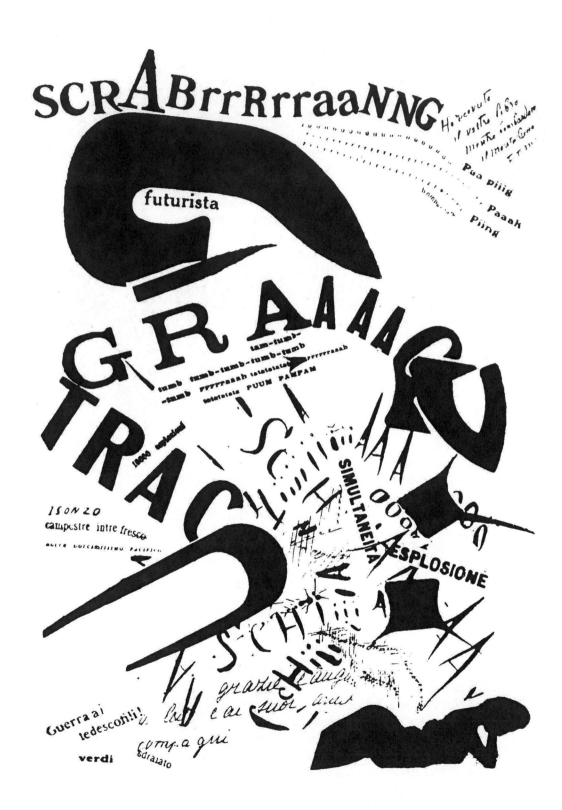

the Renaissance was not the only way of looking at things.

The other main influences on modern typographic design were the dynamic typography of the Russian Constructivist designer Lissitzky, the static asymmetric design of the Constructivist Dutch painter Piet Mondrian, and the impudent freedom of Dada.

Lissitzky, the innovator of the photo-montage poster and certainly one of the pioneers of the modern movement in design, always seems to have occupied a secondary position in its history, playing second fiddle to a number of great figures; assisting Kurt Schwitters with his periodical *Merz*, contributing to *De Stijl* with Mondrian, producing with Hans Arp *Die Kunstismen*. (This playing 'second fiddle' seems to be an inevitable part of the typographer's trade.) Lissitzky was greatly influenced by Malevich, the Suprematist painter. This resulted in his use of the diagonal axis – an influence that was to spread in the 1930s to the advertising agencies of the world.

The basic principles of Constructivism[5] (or Neo-Plasticism as Mondrian called it) and the origins of Dada are worth a brief digression. Mondrian's art was a logical development of Cubism and relied entirely on a rectangular grid structure, and an asymmetrical balance of primary colours and non-colours. (Grey, black and white.) The exquisite equilibrium of Mondrian's work was achieved usually by placing large uncoloured areas against small coloured areas. It was an equilibrium achieved by excluding any axial symmetry.

Symmetry is not merely a matter of an exact mirror image (axial symmetry) but also of geometrical forms such as, for example, rotational symmetry. In an asymmetrical layout there may often be a considerable degree of symmetry but not axial symmetry. For instance, the layout of a page of a book, which is designed as a unit, with one constant margin to the right side and a different constant margin to the left is, when viewed as a spread, perfectly symmetrical, but not axially symmetrical.

Dada was something quite different. It rejected the conventional methods and limits of painting and made use of typographic symbols, for the Dada painters regarded typography as an 'uncontaminated' medium.[6]

5. *Piet Mondrian* Michael Seuphor. Abrams, New York n.d.

6. *Dada, Monograph of a Movement* Ed. Willy Verkauf. Tiranti, London, 1957.

Vorticism: Cover design for *BLAST* No 1 by
Wyndham Lewis 1914. Printed from wood letters
in black on a cerise board.

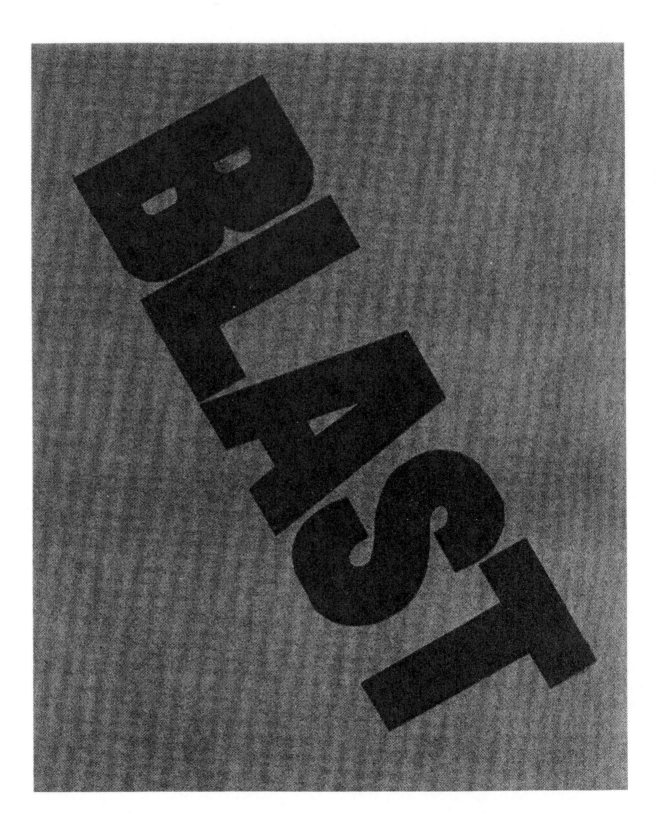

Vorticist typography. The first of Wyndham
Lewis's Manifestos, printed in *BLAST* No 1. 1914.

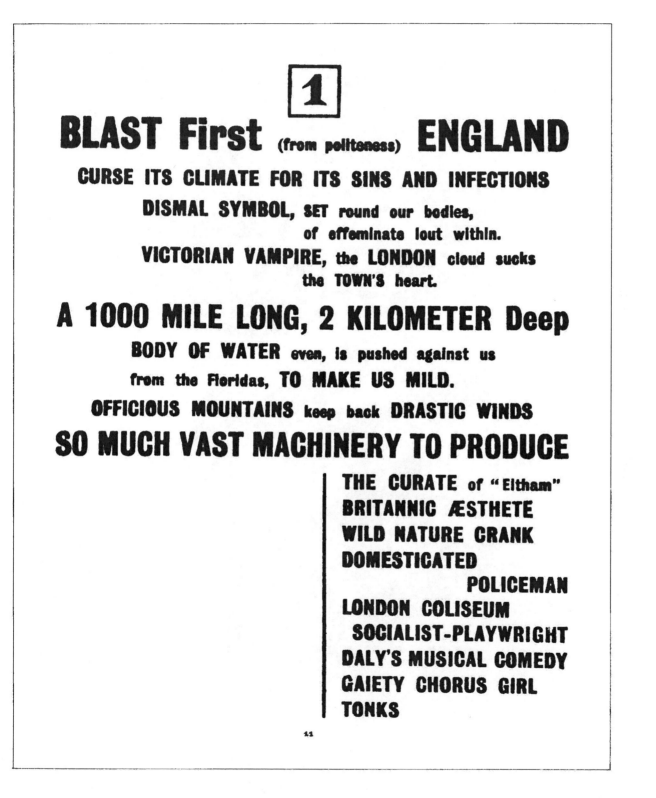

The diagonal influence of Suprematism: cover
design for *La Poèsie* by Jean Epstein. Paris 1921.

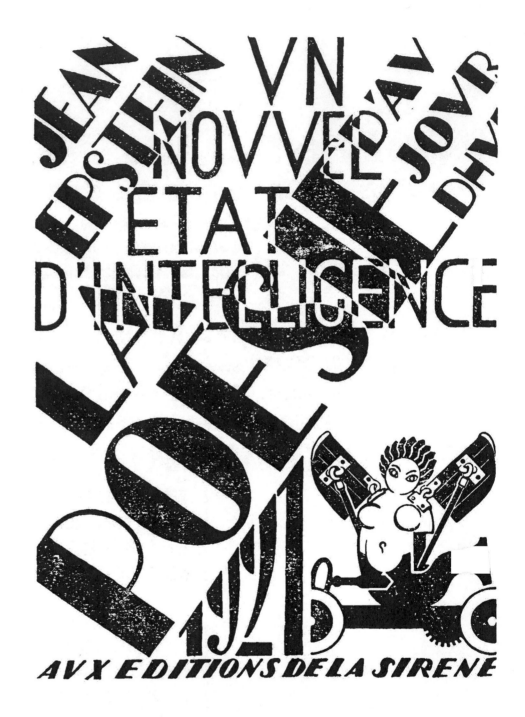

They used the symbols in the most eccentric manner, producing a kind of childish anarchy. They were attempting to explode the pomposity of much Western art, letters, even civilization. Dada provided typographers (and still does) with an exciting stimulus. Yet Dada as an entirely negative movement was inevitably self-destroying. Kurt Schwitters, whose early work had much in common with Dada, was by his intuitive art able to transform the anarchy of disordered collages and typography into something positive. His collages and typographical arrangements were much more than statements of anarchy. They were real works of art.[7]

After rejecting Dada, he came under the influence of the Constructivists. Schwitters expressed many of his ideas in the magazine *Merz* which ran for twenty-four numbers from 1923 to 1932. He worked as a typographer on the Dammerstock Exhibition at Karlsruhe under Gropius. A refugee from Nazi Germany, he eventually reached England, where he lived in semi-poverty until his death in 1944.

Helmut Herzfeld, photomonteur, like Schwitters was another whose work transcended the ephemeral quality of Dada. Herzfeld was one of the leaders of the Berlin Dada group. In 1914 he Anglicised his name to John Heartfield, as a protest against the anti-British hate campaign and retained this name for the rest of his life. The basis of Heartfield's art was his concern about social injustice. His photomontages were something more than a game of paste and scissors. He assembled conventional images in an unconventional manner and with odd juxtapositions. Heartfield's work had an immediate impact over fifty years ago and the impact today is no less powerful. George Grosz, the satyrical draughtsman, stated that he and Heartfield invented photomontage in 1916. Heartfield's montages were vital pieces of communication, such words as were used in these montages were nearly always subsidiary to the photographs.

With Dada influences the Bauhaus typographers such as L. Moholy-Nagy, Herbert Bayer and Joost Schmidt were in a mood to reject anything.

As they rejected Renaissance concepts of architecture, with its symmetry and Palladian rules of proportion, so they rejected axial symmetry and traditional margins

7. *Schwitters* Marlborough Fine Art (London) Ltd. 1960

43

Collage by Georg Grosz and John Heartfield for
Dada-merika. 1918.

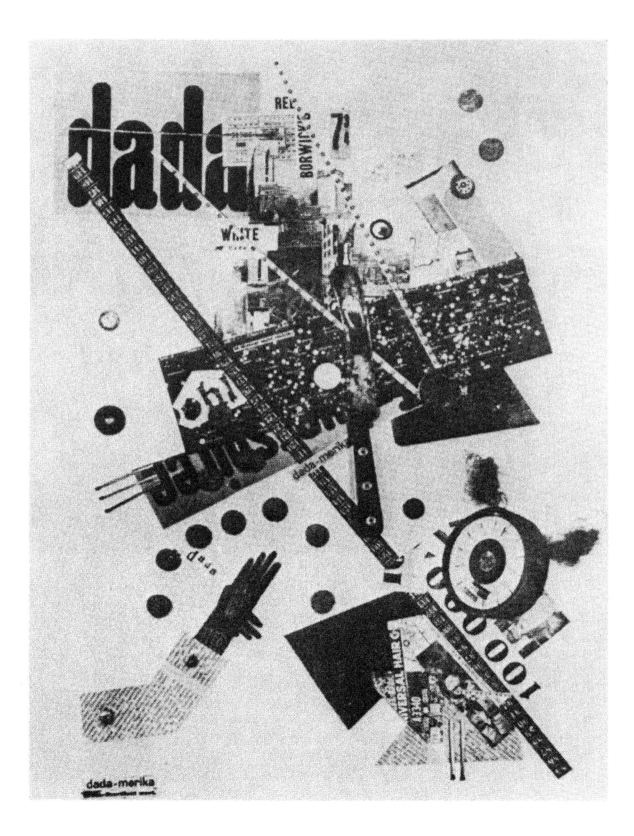

Back and front cover for *Club Dada*. 1918.

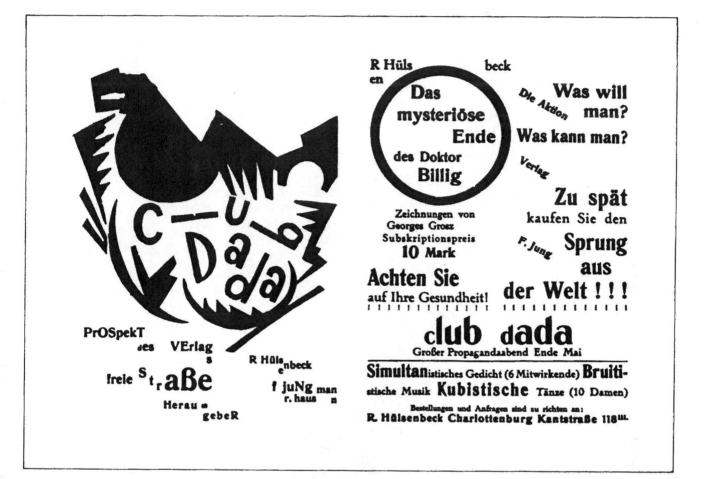

in their typography. They also rejected serifs and decoration, though at first the influence of Dada led them to use heavy rules and typefounders' borders and squares and even stock blocks.

They sought to produce the ideal typeface, not based on tradition, as Aldus had done, or on human proportions as Tory had done in his letters, but repeating Dürer's (and other early experts') use of straight lines and circles, they sought a geometrically contrived alphabet. By today's standards, their work looks heavy, clumsy and perhaps rather obvious. It did not look so then, particularly in Germany where the gothic typeface was still in everyday use.

The influence of Suprematism: cover design for the
periodical *Vyeshch* by El Lissitzky. 1922.

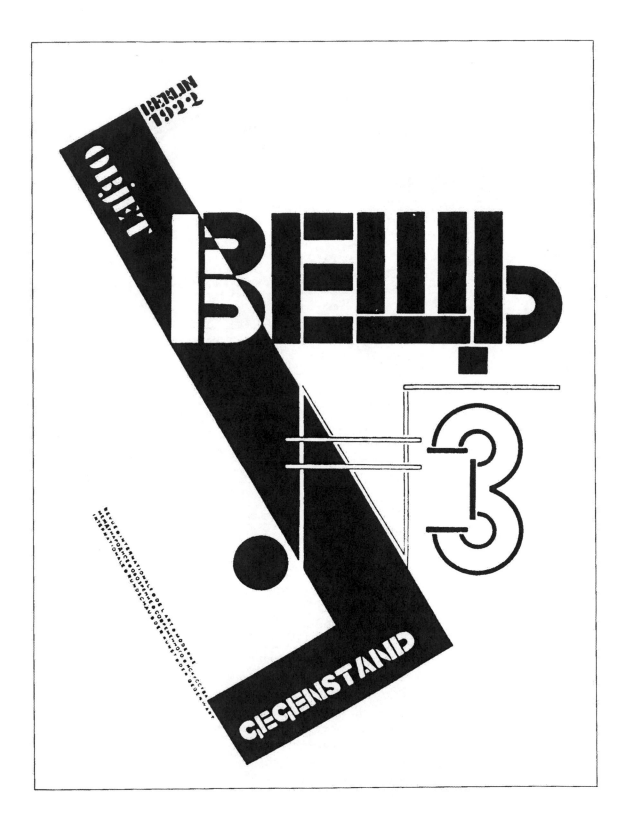

Lissitzky's design for the cover of *Das Entfesselte Theater*. 1927.

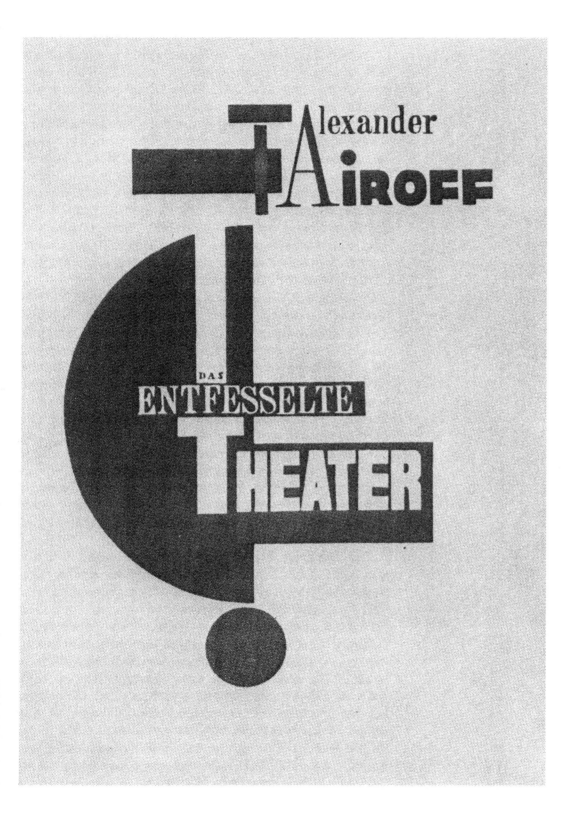

Moholy-Nagy, one of the most gifted of the Bauhaus teachers, said of typography: 'It must be clear communication in its most vivid form. Communication ought not to labour under pre-conceived aesthetic notions. Letters should never be squeezed into an arbitrary shape – like a square. A new typographic language must be created, combining elasticity, variety and a fresh approach to the materials of printing.'

Herbert Bayer, one of the instructors in the typography workshop, uttered his famous dictum: 'Why should we print with two alphabets? Both a large and a small sign are not necessary to indicate a single sound. Capital A equals small a.' This was for a while printed at the foot of the Bauhaus note paper.

As a result of this precept, the Bauhaus began in 1925 to abandon capital letters. This immediately brought Teutonic thunder about their ears, because in German, capital letters were used for all nouns. This movement for abandoning capitals in German dates back to the philologists, such as the brothers Grimm, in the 19th century. It was supported in the 1920's by Benth-Verlag (the publishers who were later to issue the DIN standards). Germany with its use of Fraktur was ripe for a typographic revolution. The change to a dark faced grotesque was a logical solution. The roman alphabet and the old style roman typeface were only used in Germany for scientific texts, which up to the early years of the 19th century had always been written and printed in Latin.

The Bauhaus typographers brought their German standards of mathematical precision to bear, so that their new typography began to assume the appearance of a blueprint governed by precise mechanical logic. The Bauhaus books, set in sans serif, with photographs boldly placed, set a new standard for illustrated books. The typographic style that emanates from this German work of the mid-1920's is now commonplace on both sides of the Atlantic. It has added another dimension to our methods of communication, though it was certainly not accepted immediately in the 1920's.

The feeling of revolt in the new movements of art, architecture and literature that were sweeping across Europe at this time was spreading to the world of

Dame vor Plakatsäule by Kasimir Malevich. c. 1920. *Stedelijk Museum, Amsterdam.*

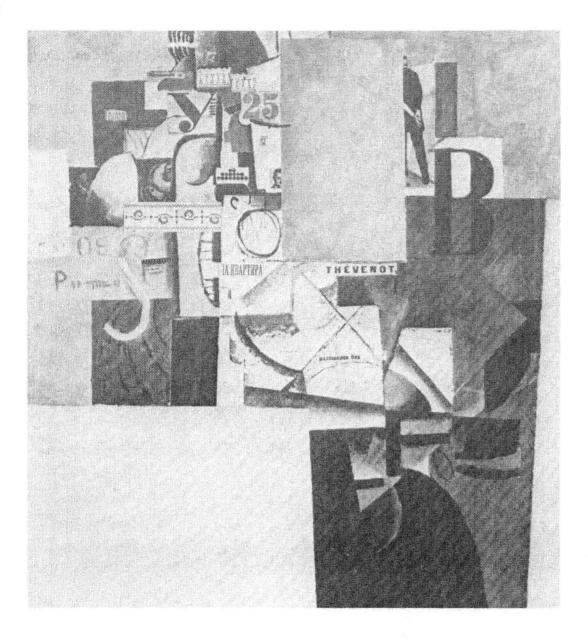

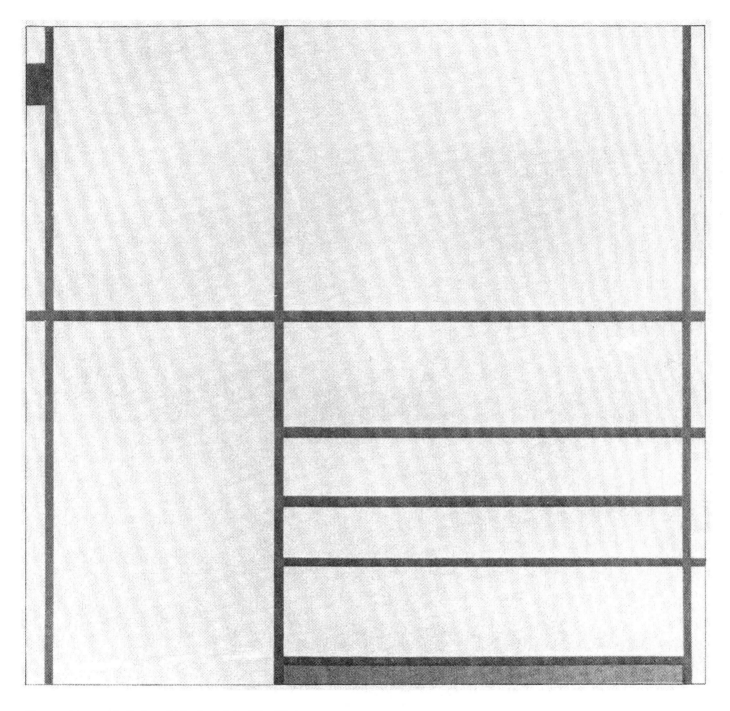

Composition with Red and Black. Painted by Piet Mondrian in 1936. *Courtesy: Sidney Janis Gallery, New York.*

printing. Writers like James Joyce were giving new form to the English language, but our typographers were not doing much about it. The German, Russian and Hungarian typographers Herbert Bayer, Lissitzky, Moholy-Nagy and Jan Tschichold, the mouthpiece of the new movement, were bringing a vital new emphasis to words by design, layout and the organization of space, by emphasis and their choice of typeface.

The cover of *De Stijl* designed by Theo van Doesburg. 1923. *Courtesy: Sidney Janis Gallery, New York.*

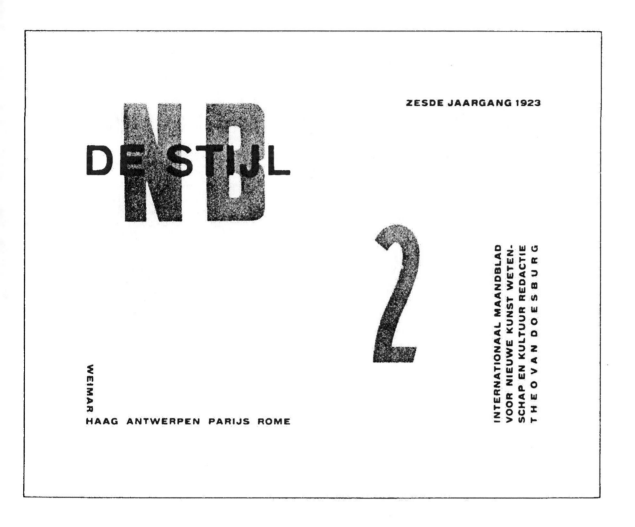

Principles for this new typography were slowly being established. They called it Functional typography on the assumption that it was based on no set of formal conventions or obsolete clichés (as most book printing was, and still is) but on design planned solely for functional ends. They also called it Constructivist typography, because it was to have a logical construction and to be in no way intuitive.

Lissitzky's design for *Merz* programme cover.
c. 1925.

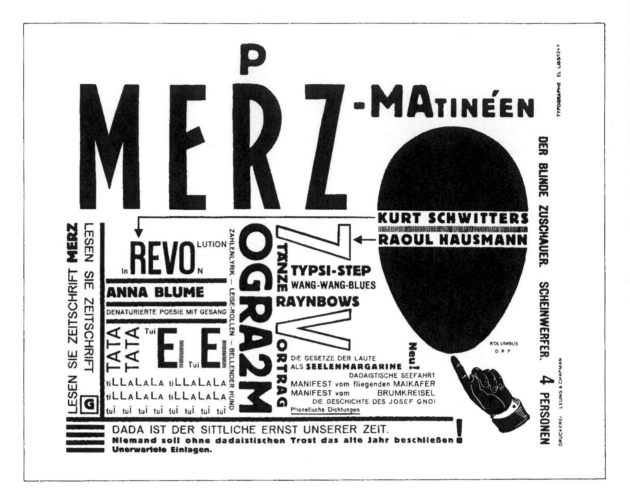

The basic constituents for the New Typography were:
Freedom from tradition;
Geometrical simplicity;
Contrast of typographical material;
The exclusion of any ornament not functionally necessary;
A preference for keeping within the range of type sizes that could be machine set;
The use of photographs for illustrations;
The use of primary colours;
The acceptance of the machine age and the utilitarian purpose of typography.

These fundamentals of the New Typography were quoted by Jan Tschichold in his *Eine Stunde Druckgestaltung* (1931). [8]

8. *Eine Stunde Druckgestaltung* Translated by Ladislav Sutnar and reprinted in *Typography U.S.A.* 1959.

Letterheading design by Kurt Schwitters who was not only a supreme *collagiste* but also a highly competent typographer in the new idiom. c. 1928

Exhibition card for the Bauhaus, designed by Herbert Bayer in 1923, (below).

STÄDTISCHES FÜRSORGEAMT KARLSRUHE
Bezirksfürsorgeverband Karlsruhe-Stadt
Postanschrift: Städtisches Fürsorgeamt Karlsruhe, Amalienstraße 35

Postscheckkonto: Wohlfahrtskasse 5343 Karlsruhe
Fernruf: 7004 7006
Geschäftszeit: 8--11 Uhr

Geschäftsstelle:

An

Bearbeitungsvermerke.

Betreff:

Beilagen:

Geschäftsstelle und Betreff in der Antwort und bei Zahlungen angeben

Ihre Zeichen

Ihre Nachricht vom

Tag

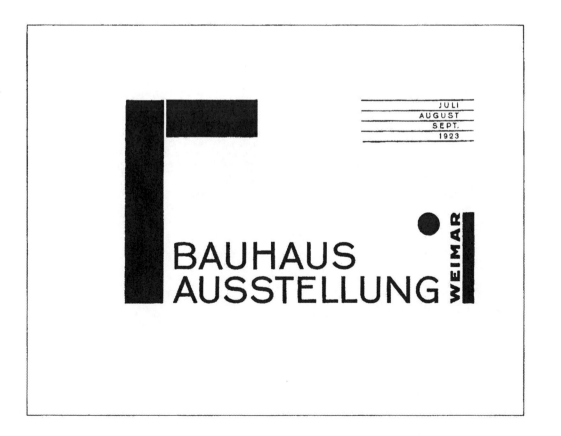

The prospectus and title-page for the first book
issued by the Bauhaus press in 1923. Designed by
L. Moholy-Nagy.

STAATLICHES
BAUHAUS

WEIMAR 1919 1923

BAUHAUSVERLAG g.m.b.h.
MÜNCHEN
MAXIMILIANSTR. 18

Das Buch, welches anläßlich der ersten Aus-
stellung vom 15. August bis 30. September 1923
des Staatlichen Bauhauses zu Weimar nach
dessen 3½jährigem Bestehen erscheint, ist in
erster Linie Dokument dieser Anstalt; es reicht
aber, dem Charakter der Anstalt entsprechend,
weit über eine örtliche oder spezifische Ange-
legenheit hinaus ins allgemeine, gegenwärtige
und zukünftige Gebiet künstlerischen Schaffens
und künstlerischer Erziehung.
So wie das Staatliche Bauhaus das erste wirk-
liche Zusammenfassen der im letzten Jahrzehnt
gewonnenen Einsichten in künstlerischen Ent-
wicklungsfragen bedeutet, so nimmt das Buch
spiegelnd Teil an diesen Fragen und bedeutet
jedem, der sich über den Stand dieser Dinge
unterrichten will, hierzu ein willkommenes Mittel.
Darüber hinaus bleibt es ein geschichtliches
Dokument. Denn das Bauhaus ist, obwohl zu-
nächst einzigartig, keine insulare Erscheinung
sondern ein kräftiger Trieb, der sich voll ent-
faltet und auch völlig sich ausbreiten wird. Das

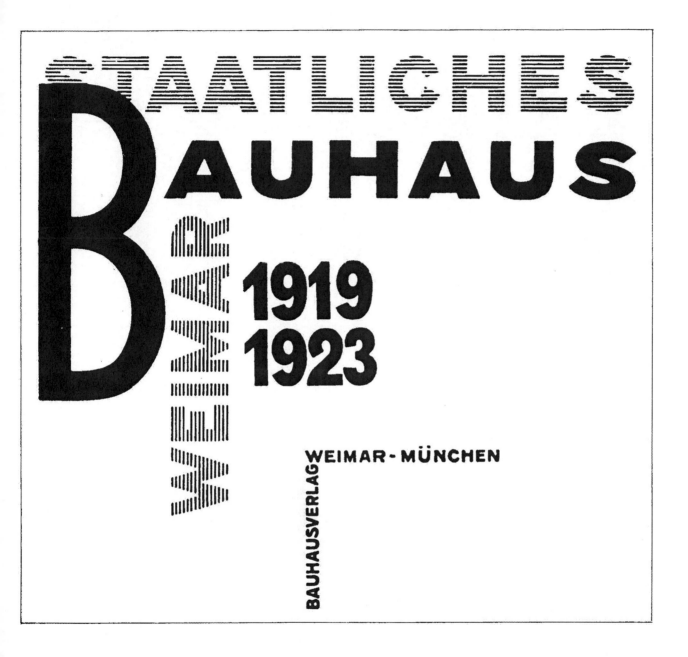

Prospectus designed by L. Moholy-Nagy, 1929.

The theatre in the Bauhaus, book design.

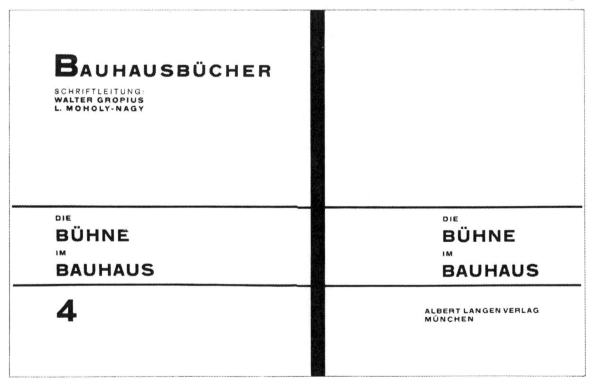

1928

2. jahrgang nr. 4
einzelheft preis rmk. 1.20

inhalt

die bauhaus-zeitschrift erscheint vierteljährlich

bezugspreis jährlich rmk. 4
einzelnummer rmk. 1.20
preis dieser nummer rmk. 1.20

abonnements bei dem verlag oder durch den buchhandel

verlag und anzeigenverwaltung: dessau, zerbster str. 16 postscheckkonto: magdeburg 16662
telefon sammel-nr. 3106
für den anzeigenteil verantwortlich:
hermann steffen, dessau.

bezugs- und zahlungsbedingungen:

abonnements haben geltung bis ende des laufenden kalenderjahres. abonnements, die 30 tage vor ablauf des laufenden kalenderjahres beim verlage schriftlich nicht gekündigt sind, gelten als um das nächste kalenderjahr verlängert. erteilte rechnungen sind so zeitig zu begleichen, daß der verlag spätestens 8 tage nach rechnungsdatum über die rechnungsbeträge verfügen kann. überfällige forderungen erhöhen sich um mahn- und inkassospesen. ausfall der zeitschriftenlieferung ohne verschulden des verlages (streik, höhere gewalt usw.) berechtigt nicht zum verlangen nach minderung des bezugspreises oder schadenersatzleistung. erfüllungsort und gerichtsstand für beide teile ist dessau.

sendungen an die redaktion: bauhaus dessau
für die redaktion verantwortlich:
ernst kállai, dessau.
für unverlangte beiträge und rezensionsexemplare keinerlei gewähr.

alle rechte vorbehalten

die bauhausbücher

verlag albert langen, münchen, hubertusstr. 27
schriftleitung: w. gropius und l. moholy - nagy

band 1 walter gropius, internationale architektur
(zweite auflage) geh 5 in leinen geb 7 rmk.
band 2 paul klee, pädagogisches skizzenbuch vergriffen
band 3 ein versuchshaus des bauhauses vergriffen
band 4 die bühne des bauhauses
geh 5, in leinen geb 7 rmk.
band 5 piet mondrian, neue gestaltung vergriffen
band 6 theo van doesburg, grundbegriffe der neuen gestaltenden kunst vergriffen
band 7 neue arbeiten der bauhauswerkstätten
geh 6, in leinen geb 8 rmk.
band 8 l. moholy-nagy, malerei, photographie, film
(zweite auflage) geh 7, in leinen geb 9 rmk.
band 9 w. kandinsky, punkt und linie zur fläche
(zweite auflage) geh 15, in leinen geb 18 rmk.
band 10 j. j. p. oud, holländische architektur
geh 6, in leinen geb 8 rmk.

neu erschienen ist:

band 11 k. malewitsch, die gegenstandslose welt, begründung und erklärung des russischen suprematismus
geh 6, in leinen geb 8 rmk.

in kürze erscheinen:

band 12 w. gropius, bauhausneubauten in dessau
band 13 a. gleizes, kubismus
band 14 l. moholy-nagy, von kunst zu leben

die sammlung wird fortgesetzt

nr. 2/3 1928 der bauhauszeitschrift
ist vollständig vergriffen!

Contents page for Bauhaus magazine, set in two
weights of grotesque and using no capital letters.
1928.

Cover for Bauhaus magazine designed by Joost
Schmidt. 1929.

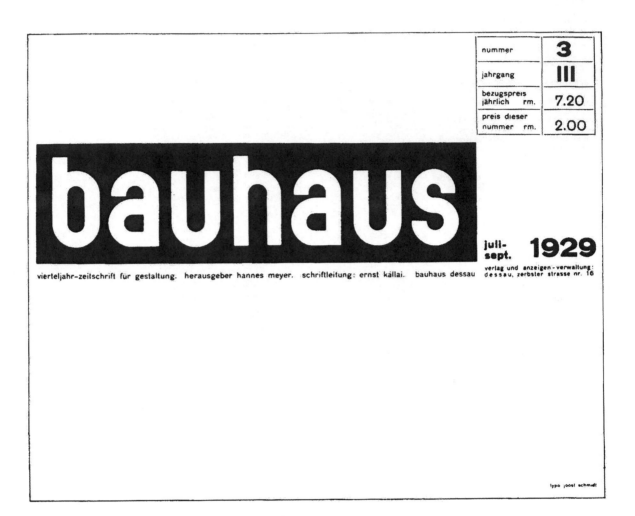

nummer	3
jahrgang	III
bezugspreis jährlich rm.	7.20
preis dieser nummer rm.	2.00

bauhaus

juli-sept. **1929**

vierteljahr–zeitschrift für gestaltung. herausgeber hannes meyer. schriftleitung: ernst kállai. bauhaus dessau

verlag und anzeigen-verwaltung: dessau, zerbster strasse nr. 16

typo joost schmidt

DIE NEUE TYPOGRAPHIE

Jan Tschichold (1902–1974) was the first person to formulate the principles of the new typography so that even printers could understand what he was talking about. Tschichold was the only one of the typographers of this modern movement who had been trained in both calligraphy and lettering. He in turn taught these subjects, first at Leipzig and then from 1926 in Munich under the type designer Paul Renner, who had already published his *Typografie als Kunst* in 1922 and was at that time working on the designs of his Futura typeface.

In 1923 Tschichold visited the Bauhaus exhibition at Weimar. This visit revolutionized his ideas. He, a

supreme classical lettering artist, decided that there was no place for lettering in modern printing design. The need was for sans serif types which, in the opinion of the typographers at the Bauhaus was the only typeface suitable for modern design. Tschichold's early work in this vein shows the influences of Lissitzky, Moholy-Nagy and Bayer. But Tschichold was still a literary man. In 1925 he published *Elementare Typographie* in the Leipzig *Typographische Mitteilungen;* in this he stated his 'Principles of Typography':

1. The new typography is purposeful
2. The purpose of all typography is communication Communication must be made in the shortest, simplest, most definite way
3. For typography to perform its social function, there must be *Organization* of its component parts, both *internal* (i.e. content) and *external* (consistent use of printing methods and materials).
4. *Internal Organization* is restriction to the basic elements of typography: letters, figures, signs, lines of type set by hand and by machine.
 The basic elements of the new typography include, in the visually organized world, the exact picture: photography.
 The basic type form is *sans serif* in all its variations; light medium, bold, narrow to expanded.
 Types with definite style characteristics or nationalist flavour, like Gothic, Fraktur or 'Kirchenslavic', are not simple enough in form and tend to restrict the possibilities of international communication.

'Of all the many varieties of typeface in use today, 'roman' is the most familiar. For many kinds of work, although not truly simple enough in form it is potentially more readable than many sans serifs.' Already he was expressing some doubts about the doctrinaire attitudes of the new movement.

In 1928 Tschichold's *Die Neue Typographie* was published in Berlin, the first book to put forward principles of typographic design that could be applied as easily to jobbing as to book printing. As a piece of book design, it wears well. It is much less clumsy

Herbert Bayer's experimental *Universal Typeface.* 1925.

Spread from *Eine Stunde Druckgestaltung* written and designed by Tschichold in 1935, after he had left Germany and moved to Switzerland.

than the contemporary Bauhaus books. It is set in a sans serif as being the only truly 20th century typeface with asymmetry as an integral factor in the design. It was a dogmatic little treatise which Tschichold later considered as immature and quite contrary to his reconsidered opinions.

He continued to refine his typographic style as he developed his design philosophy. If the Nazis had not come into power, it is hard to say how his work would have developed. Early in 1933 he and his wife were arrested. Whilst in prison he heard that he had been sacked from his teaching post at the Munich Master

Spread from a guide book to Dessau, the second home of the Bauhaus, designed by Jan Tschichold c. 1932. The combination of the elegant copper · plate script with a fat face letter used for *Bau-und Kunstwerke* is a surprising breakaway from the almost obligatory sans serif of the New Typography. Tschichold in fact used a copper plate script in his title-page of his *Typographische Gestaltung* in 1935.

Title-page for *Typographische Gestaltung* 1935.

Note three different typefaces in three lines of copy, yet it still has a classic quality about it.

Jan Tschichold:

Typographische Gestaltung

Benno Schwabe & Co . Basel 1935

Printers' School. As soon as he was released from prison, he and his family left Germany and settled in Basle with promise of work from the publishing house of Benno Schwabe and also some part-time teaching at the Basle School of Arts and Crafts.

The fact that the Nazis were so against the modern movements in art and typography and practically everything else for that matter, might have strengthened Tschichold's doctrinaire belief in *Die Neue Typographie*.

Spread from *Typographische Gestaltung*. The photogramme includes a self-portrait of Lissitzky. Tschichold has used the same condensed bold Egyptian that he used on the title-page, for the running heads.

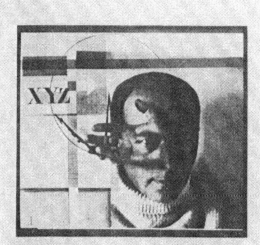

In fact the reverse happened. As early as 1935, in an article he had written for *Typographische Monatsblatter*, he admitted that there was a place for centred typography as well as for asymmetrical design. This turn-round of his views dumbfounded his followers, yet there was logic in this recantation. He proved his good sense when in 1941 he redesigned over 50 volumes for the Birkhäuser Classics in Basle in an immaculately centred style.

The Penguin Shakespeare series designed by Jan Tschichold in 1949. The cover was printed in black and red.

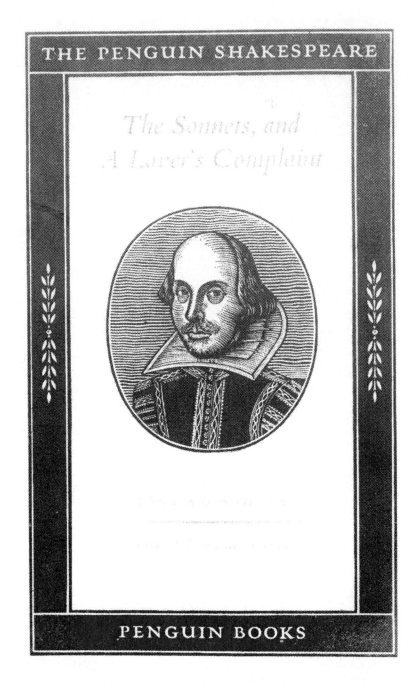

64

SHAKESPEARE'S SONNETS

I

From fairest creatures we desire increase,
That thereby beauty's rose might never die,
But as the riper should by time decease,
His tender heir might bear his memory:
But thou contracted to thine own bright eyes,
Feed'st thy light's flame with self substantial fuel,
Making a famine where abundance lies,
Thyself thy foe, to thy sweet self too cruel:
Thou that art now the world's fresh ornament,
And only herald to the gaudy spring,
Within thine own bud buriest thy content,
And tender churl mak'st waste in niggarding:
Pity the world, or else this glutton be,
To eat the world's due, by the grave and thee.

2

When forty winters shall besiege thy brow,
And dig deep trenches in thy beauty's field,
Thy youth's proud livery so gaz'd on now,
Will be a totter'd weed of small worth held:
Then being ask'd, where all thy beauty lies,
Where all the treasure of thy lusty days;
To say within thine own deep sunken eyes,
Were an all-eating shame, and thriftless praise.
How much more praise deserv'd thy beauty's use,
If thou could'st answer this fair child of mine
Shall sum my count, and make my old excuse
Proving his beauty by succession thine.
This were to be new made when thou art old,
And see thy blood warm when thou feel'st it cold.

In March 1947, Tschichold came to England on the invitation of Allen Lane to redesign Penguin Books. He immediately formulated the Penguin House Rules. These rules are something that every book designer should know by heart. (See page 101). The result of his work at Penguins proved to be a triumphant success, however much the English printers disliked being jerked out of their slovenly habits.

In an article Tschichold wrote for *Schweizer Graphische Mitteilungen* in reply to a fierce attack made on him in the same paper by Max Bill, the Swiss artist and architect, Tschichold said:

'The derivation of typographic rules from the principles of painting formally known as 'abstract' or 'non-objective' and now called 'concrete' (Lissitzky, Mondrian, Moholy-Nagy) resulted in a valuable and temporary novel typography. But it seems to me no coincidence that this typography was practised almost exclusively in Germany and found little acceptance in other countries. Because its impatient attitude conforms to the German bent for the absolute, and its military will to regulate and its claim to absolute power reflect those fearful components of the German character which set loose Hitler's power in the second world war'. He goes on to say 'The New or Functional typography is well suited for publicising industrial products (it has the same origin). Yet its means of expression are limited because it strives solely for Puritanical 'clarity' and 'purity' . . . there are many typographic problems which cannot be solved on such regimented lines without doing violence to the text . . . Many jobs, especially books are far too complicated for the simplifying procedures of the New Typography.' Tschichold finally remarks that some present day typography, like his own work between 1924–35, is marked by a naive worship of so-called technical progress. He also makes the useful point that unjustified setting, which was first introduced by Eric Gill in his *An essay on typography* in 1930 is only an apparent simplification. It is useful for hand setting, but the machine can justify without effort. [9]

The new typography brought radical new concepts to the whole idea of printing design. It acted like a purge and has given us a new design language for

9. *Jan Tschichold: Typographer* Ruari McLean. Lund Humphries, London, 1975.

tackling a thousand new design problems for which there was no precedent; problems such as the design of photographically illustrated books. Until the typographers of this new way of thinking gave us a way of dealing with these things, they usually looked something like Great-Aunt Mary's family photograph album. But as Tschichold showed, the new typography was not the answer to every problem and its self-imposed rules produced greater limitations than anything it was trying to replace.

Tschichold was an intuitive designer, with a very high appreciation of the exact placing of type on the paper. His work in the 'new typography' manner was a much refined version of the early Bayer and Moholy-Nagy work. His book designs in the traditional manner can hardly be faulted.

It seems now that Tschichold's conversion in 1940 was a very personal one, due at least in part to his reaction against 'militaristic Nazi-minded New Typography' and his return to Renaissance typography was not a rejection of the new typography based only on aesthetic or functional grounds. Art cannot exist in a vacuum, and though typography may be only a minor art, it cannot be divorced from outside influences.

A SUMMARY OF INFLUENCES

Movements set in motion a chain of reactions so that you may all end up at the point where you started. There is not much you can do about it except to be aware of it. The day you live is today, the way you express yourself is today's way. For you cannot isolate printing from other activities; as a service industry it is vulnerable to every change of fashion and taste, and most vulnerable to the changing face of modern art.

These then are some of the art and design influences that have affected modern typography: Cubism, Dada, Constructivism and Suprematism, Art Nouveau, the Arts and Crafts movement and the Bauhaus. The Cubists established that the twentieth-century painter had other things to do besides providing visual likenesses of things, scenes and people; they also provided at least one approach for modern graphic design, of which artists working for advertising in the 1930's made good use.

The Dadaists have given us a freedom of expression and have smashed the old conventions of typographic communication.

Russian Constructivism was essentially a three-dimensional art, primarily concerned with the exploration of space, not in today's interplanetary sense, but as the fundamental element in all design. Basic design exercises with paste and paper or drinking straws and paper clips, where space can be trapped in form, derive directly from the work of the Constructivists. The most valuable contribution to typography that Constructivism gave was this appreciation of controlled space.

Mondrian and Constructivism have produced a new order, and on Mondrian's dynamically balanced grid you can reassemble the typographic chaos of the Dadaists.

Suprematism with its insistence on the diagonal may now appear to have played only a very small part in the development of modern typography, yet it was Lissitzky who was one of the first to synthesize the modern art movements and to convert them usefully to typographic ends, so that the relationship of forms, the dynamic tensions of diagonals against verticals, the purity of primary colours, the studied organization of the pages and the repetitive rhythm of carefully placed units would all help to clarify and increase the sense of the copy.[10]

Art nouveau has offered us a stylistic freedom with decorative asymmetry.

The Arts and Crafts Movement, and particularly the work of William Morris, have set the scene for modern industrial design. For it was Morris who identified art with everyone, who rejected Renaissance culture for the simpler world of the Middle Ages, when art was craft and the craftsman was an artist and there was joy in creative work. And it was Morris who brought the artist back into the world of industrial design, and revitalised printing by emphasising the value of craft knowledge of media and materials.

It was also Morris who inspired the founders of the Bauhaus, whose teachers (designers and artists such as Moholy-Nagy and Paul Klee) at last began to hammer out a philosophy for modern design.

These are the influences that I believe have fashioned

10. *Anatomy of Printing* John Lewis. Faber, London and Watson Guptill, New York, 1972.

Bifur designed by the French poster artist Cassandre (A. J-M. Muron) c. 1931 for Deberny-Peignot. It is so named because ot its 'bifurcation', that is, its form has been split into two components, a black and a grey. This is perhaps the last really original display typeface.

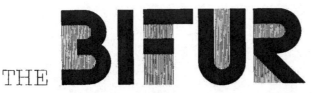

THE **BIFUR**

DESIGNED BY CASSANDRE, DERIVES ITS NAME FROM "BIFURCATION", BECAUSE ITS FORM HAS BEEN SPLIT INTO TWO COMPONENTS : BLACK, AND A LINEAR ARRANGEMENT WHICH CREATES A GREY TONE. THUS, THE BIFUR IS COMPOSED OF TWO COLOUR VALUES

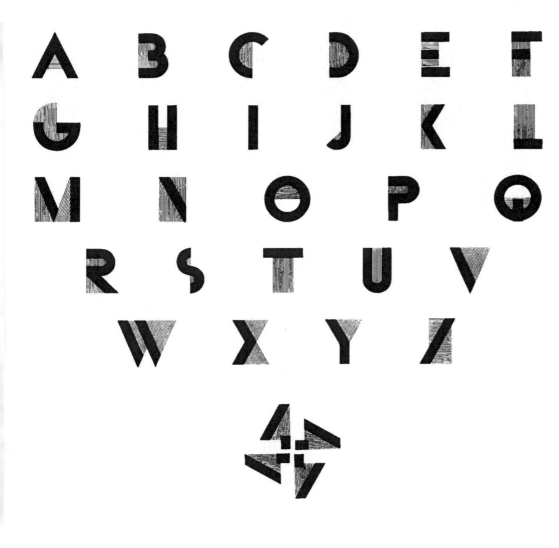

DEBERNY-PEIGNOT, TYPEFOUNDERS, PARIS, XIV

Horsepower: poster designed by E. McKnight Kauffer c. 1933, combining elements of Suprematism and collage. Printed in blue, yellow and black.

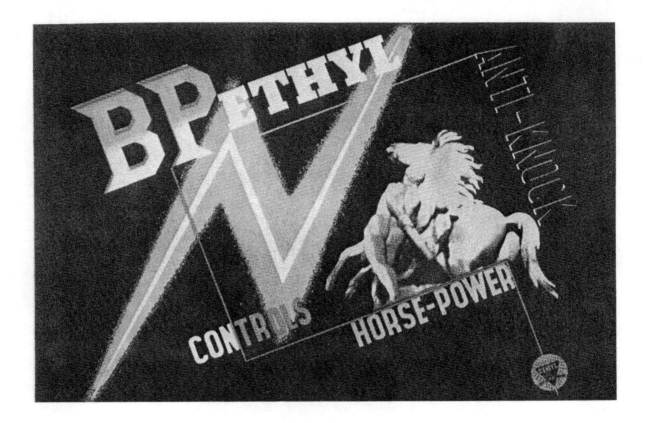

the work we are doing today. The humbling thing about all this is that it is nearly a hundred years since Morris started making his prophetic utterances, it is seventy years since the first Cubist paintings were done, it is nearly sixty years since the Bauhaus was founded and over fifty years since the Dada movement came to an end. It is over thirty years since Mondrian died. The creative artist (if not the successful one) is always a generation or so ahead of his time.

2. Modern trends in typographic communication

The language of the typographer today – as always – must depend on words, and words are made up of recognisable symbols – letters. This immediately presents a problem, and perhaps a contradiction. Modern art has given the graphic artist a visual language of expression. He can dispense with the traditions of the Renaissance, and have nothing to do with axial symmetry and the classical proportions – and then find that he is landed with a set of Renaissance symbols – the roman and italic typefaces, in which to express his latterday thoughts. This is but one of the contradictions that our modern typographer has to face; there are hosts of others. These often belong to the job in hand; they are a kind of occupational hazard. But one thing is certain and that is that the typographer's main job is to communicate with as little interference as possible an author's or copywriter's message.

Language is not a static thing. The ever changing value of words is shown by the acceptance of foreign expressions and slang, Transatlantic or European into common English usage. Even more striking than this is the revitalising effect a poet can have on our tongue, by turning words topsy-turvey and inside out. If this seems far fetched, take Dylan Thomas's opening lines to his *Under Milk Wood:*

'It is Spring, moonless night in the small town, starless and bible-black, the cobble streets silent and the hunched, courters'-and-rabbits' wood limping invisible down to the sloeblack, slow, black, crowblack, fishing-boat-bobbing sea. The houses are blind as moles (though moles see fine tonight in the snouting, velvet dingles) . . .'

Quite apart from the imagery of the play on words, such as 'sloe black' and 'slow black', Thomas injected new life into the night scene by transposing 'snouting velvet' from the moles to the dingles. A snouting velvet mole is just a snouting velvet mole, but when one hears snouting velvet dingles the imagery comes to life.

Thomas, like James Joyce before him, has widened the scope of the English language and language, like visual images, needs revitalising or it dies.

The same need applies to the graphic arts. The painter is no longer content to work with existing conventions, which fast become clichés. He is constantly seeking new

means of expression. He sets the pace, the graphic designer follows. Yet in odd and different ways they can cross-fertilize each other, for instance in the so-called Pop Art of the sixties there was a wealth of typographic symbols. With Conceptual Art, the typographer may have taken over!

The tension provided by the conflict that lies between the visual impact of design and the literary sense is the problem always facing the typographer and, if he is willing to accept it, always challenging him to seek new solutions. Here is his salvation. Inevitably he is a creature of his time and is influenced by the thoughts, tastes, fashions and manners of his day. Within that framework of conflicting restrictions, he has to solve his problems. If he accepts the fact that 'the seeds of the solution of any problem lie within the problem itself', he will be on the way to solving it. But the way he solves it in the year 2000 will not be the same as today.

Students, naturally enough, welcome ready-made answers to design problems. As Morison remarked, 'The process of thinking is, in fact, so painful that many prefer to ignore this essential means to the right solution of a problem'. What students have to learn is something much less facile than existing clichés, and that is how to assess what their problem is. Once the design problem is seen clearly, the way is open. How well, and in what way it is solved, depends on many things, including the sense of words, the conventions in which they are presented, the limitations of eye, the effects of materials, process and methods of production, and the needs for (and aids for) legibility.

Attempts to lay down firm principles, with the sole exception of Stanley Morison's classic *First Principles of Typography*, have usually resulted in rather woolly utterances. Lissitsky, pioneer Constructivist, Suprematist and one of the originators of photomontage posters said, 'Concepts are connected by conventional words and shaped in letters of the alphabet . . . the new book demands new writers!'

This is not much help, yet by precept Lissitsky established the dynamic value of the diagonal axis and of geometrical repetition and organisation in book design.

Herbert Bayer, another of the pioneers, said in 1965: 'Typography is not self expression with predetermined aesthetics, but it is conditioned by the message it visualizes'. This is nearer the mark. This last sentence is indeed the key to any set of typographic principles.

Morison's *First Principles* was originally published in 1929. A new French edition appeared in 1965 without significant change. Morison in a witty introduction to the latest edition admitted that: 'The reprinting of this tract without change must be difficult to justify'. He stood for tradition, but a 'tradition that is more than an embalming of forms customary in states of society long since cast aside'. He continued: 'Tradition is another word for unanimity about fundamentals which has been brought into being by the trials, errors and corrections of many centuries.' Lissitsky, Bayer and Morison, so different in their attitudes, have one thing in common — a belief in the importance of transmitting an author's message to a reader. Beyond this I cannot think there are any absolute typographic laws, only this overriding one of the making clear an author's words to a reader. Everything else must be subsidiary to this. The possibilities for experimental typography are enormous. The few illustrations in the final chapter give some indication of what can be done with type.

Your successful typographer can move in more than one channel of taste and fashion. He can, in the most modern idiom, be completely self-effacing. Such a one is the Swiss sculptor and typographer Max Bill; this kind of typography is typical of the Swiss. In the hands of a designer like Max Bill, it is completely satisfying; in the hands of others less gifted, it often attains an immaculate dullness. Or else he can be a complete extrovert, a neo-Dadaist, tearing his words apart, setting half his message in six point and the other half in 8-line wood letters. His message if he is successful, comes over just like a slap from a wet towel: the others soothe one, graciously perhaps, to sleep.

The book typographer of today, of course, has a mountain of tradition to climb over before he can produce books that reflect the character of today and not that of sixteenth century Italy and France. And at the end of his struggle he may find that the old ways are best!

Aabcdefghijkl

San Francisco

Equal working

A comparison of sans serif type designs.

Top: Gill sans designed by Eric Gill in 1928.
Centre: Futura designed by Paul Renner in 1928.
Bottom: Grotesque Series 215. A re-drawing of a nineteenth century typeface.

The actual function of the book is now at last being challenged, particularly its anonymous non-visual appearance. As long ago as 1918, an effective attempt at a visual book was made by Guillaume Apollinaire in his *Calligrammes (Poèms de la Paix et de la Guerre)*. The poems in this book were laid out in a manner that symbolized their contents. These were by many years the forerunners of Concrete Poetry, where poets once again use words in a visual way.

Before considering the possibilities of such experimental typography, it is worth sparing some thought on the actual typefaces that one uses for text setting.

CHOICE OF TYPEFACE

A sans serif seemed the obvious choice to the German typographers of the 1920's. The argument waged so hotly by the traditionalists against the sans serif typeface is that it is not as readable as the old style letter with serifs. In the conventional layout with twelve words to the line it is not. But is that the right format, and the right length of line for this day and age?

For complicated setting, such as the accounts pages of company's annual reports, the use of sans serifs of different weights can provide legible and pleasant looking pages. The average line in newspapers, tabloid or otherwise, is five to seven words. This is a line that can be taken in at a gulp, or at least at one glance. After all we do not read by letters or even words, but by groups of words. So, if the line is short enough for one glance reading, I have no doubt that a sans and a bold one at that, would be just as readable. This opens up exciting possibilities, but what form should the sans take?

The three basic letterforms that sans serif alphabets follow are: firstly the compass and set square sort, such as Rudolf Koch's Cable and Paul Renner's Futura or American Typefounders Spartan; secondly the Renaissance style letters that gave their classical proportions to Gill Sans; and lastly the grotesques or gothics (as some of them are called) which are closer in some ways to black letter than to the normal roman. For the last forty years the concensus of opinion would have come down fairly heavily on the side of the grotesques.

'It's raining', a translation of one of Guillaume Apollinaire's poems in *Calligrammes,* originally published in 1918. Reproduced from *Apollinaire: Selected Poems* translated by Olive Bernard and published by Penguin Books. 1965.

It's Raining

it is raining women's voices as if they were dead even in memory

you also are raining down marvellous encounters of my life o little drops

and these rearing clouds are beginning to whinny a whole world of auricular towns

listen to it rain while regret and disdain weep an old fashioned music

listen to the fall of all the perpendiculars of your existence

Narrow setting and wide margins: book design by Max Bill for *Sophie Taeuber-Arp*, 1948. Titles and subheads thrown outwards.

Im Freundeskreis erweckte das letzte Blatt der Schwarzweißfolge, die 1943 aus dem Nachlaß der unter tragischen Umständen verstorbenen Künstlerin Sophie Taeuber-Arp erschienen ist, seltsame Ahnungen und Gedanken. Gleicht·diese dunkle, scharfgeschnittene Silhouette nicht einem Kahn mit hochgezogenem Segel? Deutet dieses letzte Bildvermächtnis nicht auf das Motiv einer Überfahrt hin, weg von dem diesseitigen Leben, einer jenseitigen Ferne zu?

Als ich das schmale Bändchen mit den neun Zeichnungen das erste Mal in den Händen hielt, Bild um Bild darin durchging, so wie man sein Ohr einer aus unbekannter Quelle zuströmenden Melodie öffnet, da sahen mich alle diese abstrakten Figuren wie fremde Runen stumm, doch eindringlich als eine geheime Abschiedsbotschaft an. Noch wußte ich damals nicht, daß diese Bilderfolge innerhalb weniger Tage, drei Wochen vor dem Hinschied der Künstlerin, aus stiller Versenkung heraus als ein einheitlich und unbewußt ablaufender Vorgang entstanden war. Immer und immer wieder mußte ich darauf zurückgreifen, ihre mögliche Bedeutung erwägen. Von der reinen Größe und hierarchischen Wucht eines gesetzmäßig sich vollendenden Schicksals fühlte ich mich suggestiv angesprochen.

Die drei ersten Zeichnungen heben mit dem Motiv einer vierfach ausstrahlenden Doppelsonne an. Ein von Gegensatzspannungen erfülltes Zwillingsgestirn steht in der Mitte. Die Hauptringe brechen jeweils meist nach oben hin auseinander. Der vollere Kreis sinkt dunkelbefrachtet zur Tiefe. Kleinere Segmente bilden eine Dreiergruppe. Das am weitesten aus dem Zentrum geworfene Stück liegt jedesmal links, auf der Seite des Herzens, des Gefühls, des Unbewußten, der Seite, die in den Mythen und Weissagungen der Völker als Symbol des Weiblichen, oft auch als die unheilbringende Richtung gilt. Nach links also wird das Einzelstück hinausgeschleudert, von dorther wie magisch angezogen, in eine einsame Stellung gedrängt.

In der zweiten Zeichnung, bei der sich das Schwarz zur empfangenden Schale formt, bildet das nach oben abgesprengte Kreissegment mit den in der Mitte in Unruhe geratenen Formen annähernd ein großes Fragezeichen, das sich in ein helles Licht emporschlängelt. Die Dreizahl der aus dem Umbruch entstandenen Fragmente erscheint dem Zei-

**Die letzten neun Zeichnungen von
Sophie Taeuber-Arp**
von Hugo Debrunner

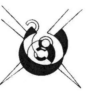

The use of a wide margin for both headings and illustrations. Design by Max Bill for *Sophie Taeuber-Arp*.

univers
univers
univers

Three weights of Univers designed by Adrian Frutiger.

The compass and set square sans serifs, although mechanically precise are in some way less readable than the others, with certain ambiguities such as the lower case 'a' with its resemblance to the small letter 'o'.

The classical form used by Eric Gill for his large family of sans serifs, though widely applauded at the time of its production, is not a satisfying form when cast in hot metal. Gill's own comment, when being complimented on these sans serif letters, was: 'Yes, but how much nicer if they had had serifs'. Also, like so many of Gill's typefaces (Perpetua is an example), the letters do not combine closely enough into words, thus ignoring Morris's first principle that the face of the letter should be as nearly conterminous with the body as possible, in order to avoid undue whites between the letters. This is to some extent an inherent fault in hot metal typesetting. The classical Gill Sans (Series 262) in normal text setting sizes used to look like an impoverished relation of Gill's own roman typefaces Perpetua or Jubilee. Now with the flexibility and the adjustable inter-letter spacing of photo-setting, Gill Sans has come into its own once again. It has become a very successful series of related text faces.

Finally the grotesques; these types are based on a series of typefaces first cut in England in the 1830's and later in Germany and America. The first sans serif (capital letters only) was actually shown by the Caslon Letter Foundry in 1816 and there called 'Two-line English Egyptian'. These types were usually called grotesques in England and gothics in America.

Blake, Garnett & Co, Caslon's successors, expressed some individuality in the 1830's by calling them 'sans surryphs'.

The early grotesques were as weighty as black letter until the Caslon firm showed a variety of weights in their specimen book of 1854. Today we have a wide variety to choose from. For text uses, Deberny & Peignot's Univers designed by Adrian Frutiger, now marketed by A.T.F. in America and by the Monotype Corporation in England, is the most thorough attempt to produce a related series of sans serif letters since Eric Gill's sans in the 1930's. Univers has twenty-one different series. The small sizes of the normal series are

Typefaces with a large x-height more suitable for an age accustomed to reading sans serif signs with their truncated ascenders and descenders.

Top: Century Schoolbook, Monotype series 650.
Centre: VIP Palatino.
Below: Plantin Light, Monotype series 113.

uniquely readable. This is partly due to the rather expanded form of these letters, which are wider in set than the other grotesques commonly used for text setting.

For display use, there is today a wide range of grotesques available, ranging from very condensed letters to bold, wide and fat letters. Obviously sans serif requirements for either text or display use are very adequately catered for. Whether sans serif typefaces are the ultimate answer to text setting is of course more than debatable. Reading habits die hard and, with nearly five hundred years of unbroken use of the roman typeface, it is clear that the roman serif letter may still have plenty of life in it. Letters are after all recognition symbols and if in a well designed letter a serif adds to the recognition value, it is earning its keep. It is a point for discussion as to whether the serif does aid letter recognition, but it is certainly an aid to word or line reading. Whether or not we have yet attained any completely satisfactory typefaces with serifs for modern offset printing conditions is open to doubt. The conclusion must be that there is more than one way of typographic communication and that there is room for more than one style of typeface.

For instance, the modern newspaper, in a rough and ready manner, has forged a fairly readable way of presenting its news. With all its faults of layout, setting and typefaces, it avoids the besetting sin of the purist, whether he is a traditionalist or a modernist, and that is the absolute crushing boredom of monotonous attention to precepts, precedents and rules.

To revert to typefaces as alternatives to grotesques, I would suggest that typefaces with a large x-height are more suitable for an age accustomed to reading sans serif signs with their truncated ascenders and descenders. Obvious examples of typefaces with a relatively large x-height are Century Schoolbook, Plantin Light and Monophoto Apollo, which, though it has longer ascenders than the other two faces, has pleasantly small capital letters and numerals. VIP Palatino is another large x-height typeface that is most readable.

abCenturydefg
qrSchoolbook

abcdefghijklmno
ABCDEFGHIJKL

Typographers
will be required

ABCDEFGHIJKLMNO
abcdefghijklmnopqrst
ABCDEFGHIJKLMNOPQR

24pt Apollo, Monophoto Series 645.

Unjustified setting in Eric Gill's *An Essay on
Typography*, set in Joanna, the most pleasing of his
typefaces. About the bizarre typefaces in his
Figure 18, Gill said that 'a good clear training in
the making of normal letters will enable a man to
indulge more efficiently in fancy and impudence'.

Signs for the University of Essex designed by ▶
James Sutton.

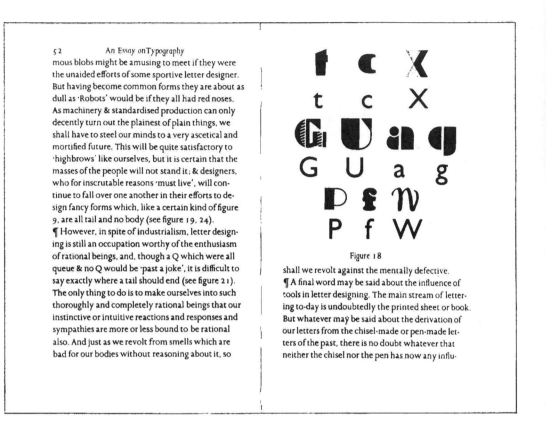

5 2 An Essay on Typography

mous blobs might be amusing to meet if they were
the unaided efforts of some sportive letter designer.
But having become common forms they are about as
dull as 'Robots' would be if they all had red noses.
As machinery & standardised production can only
decently turn out the plainest of plain things, we
shall have to steel our minds to a very ascetical and
mortified future. This will be quite satisfactory to
'highbrows' like ourselves, but it is certain that the
masses of the people will not stand it; & designers,
who for inscrutable reasons 'must live', will con-
tinue to fall over one another in their efforts to de-
sign fancy forms which, like a certain kind of figure
9, are all tail and no body (see figure 19, 24).
¶ However, in spite of industrialism, letter design-
ing is still an occupation worthy of the enthusiasm
of rational beings, and, though a Q which were all
queue & no Q would be 'past a joke', it is difficult to
say exactly where a tail should end (see figure 21).
The only thing to do is to make ourselves into such
thoroughly and completely rational beings that our
instinctive or intuitive reactions and responses and
sympathies are more or less bound to be rational
also. And just as we revolt from smells which are
bad for our bodies without reasoning about it, so

Figure 18

shall we revolt against the mentally defective.
¶ A final word may be said about the influence of
tools in letter designing. The main stream of letter-
ing to-day is undoubtedly the printed sheet or book.
But whatever may be said about the derivation of
our letters from the chisel-made or pen-made let-
ters of the past, there is no doubt whatever that
neither the chisel nor the pen has now any influ-

JUSTIFIED OR RAGGED SETTING

From the time Moholy-Nagy said: 'Letters should never
be squeezed into an arbitrary shape – like a square,' the
typographers of the modern movement started to aban-
don justified setting. In 1931 Eric Gill in *An Essay
on Typography* made use of ragged setting, and very well
set it was with such judicious use of word breaks at
the end of lines that the reader is hardly conscious that
the line is not justified! In fact, one page in the second
edition of that book was set justified, whether by
accident or not, I do not know. Gill wrote about ragged
setting in his *Essay*: 'Legibility in practice amounts
simply to what one is accustomed to . . . Equal length
of line is of its nature a *sine qua non*: it is simply one
of those things you can get if you can; it satisfies one's
appetite for a neat appearance, a laudable appetite, but
has become something of a superstition.' Tschichold's
reply to this was: 'The ragged right setting . . . has less
point in machine than in hand composition for while

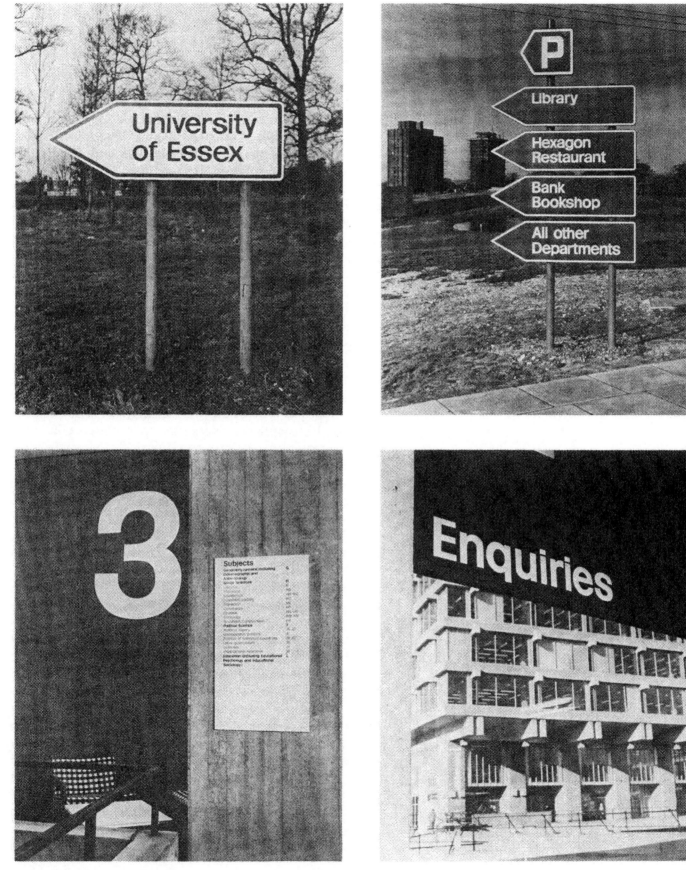

the hand compositor must take trouble to justify lines evenly, the machine takes care of this evenly and well. So it is only an apparent simplification and apparently modern in form.'

Those are the words of the masters. It is certainly better to set short lines of less than 36 characters unjustified. Otherwise it is a matter of taste. For normal text books, fact or fiction, the use of conventional formats and justified setting is still the most satisfactory method. For heavily illustrated books, with pictures integrated with the text, one could use either justified or unjustified type. Do not however imagine that unjustified setting is any more functional than justified, or any more modern for that matter.

DISPLAY TYPOGRAPHY
It is not difficult to lay down certain principles for the typography of books. To establish principles for typographic display is a very different matter, since display covers such a multiplicity of typographic uses ranging from every kind of advertising activity on hoarding, billboard, newspaper or television screen, to labels and all kinds of packaging, to letterheads and all sorts of stationery, to, in fact, every kind of ephemeral use. The importance of conveying the sense of any message is clear enough, but there are many other limitations and factors to consider.

Having established the form of the message, the next thing is to decide on what typeface is most suitable. Is there any yardstick to help one judge whether to set an advertisement or a letterhead in a fifteenth-century Venetian or a twentieth-century grotesque. At least one question one can raise is: is a letter A or B or C designed in Venice in 1468 the right A or B or C for today? You can argue it either way, but one thing is certain and that is, if Nicolas Jenson or Francesco Griffo or any of the great fifteenth or sixteenth century writing masters such as Arrighi or Tagliente were alive today the letter forms they designed for newspapers or poster hoarding would probably look very different from the ones they actually produced in the fifteenth or sixteenth centuries.

It is, I think, worth looking a little more closely at

some of the occasions when display typography is needed, to see if, at least for specific uses, there are any valid principles which one can usefully follow.

RULES FOR DISPLAY

Display typography means any kind of typesetting which is meant to catch the eye, whether it is on poster hoarding, newspaper headline, television screen, package or label. The rules of clarity and legibility that one follows for text setting may not necessarily apply for display work.

In any kind of advertising, the eye of the reader has to be caught, intrigued and cajoled into reading the copy. I would think that any typographic trick is justified. Beautiful typography has no place here. Ugliness is a perfectly permissable feature of such typography. Anyhow, who is to say what ugliness is? Though it may be an arch misconception to say that function is beauty, there is no reason to suppose that ugliness cannot most functionally serve the needs of advertising — so much so that it perhaps ceases to be ugly! The conservative printers of the early nineteenth century reviled the new heavy fat faced letters of Thorne and Figgins which were so much more effective for bills and posters than the roman typefaces. Today we regard those posters with affectionate awe. Constructivist typography produces similar reactions, yet it is the foundation of good modern display work. Ugliness is often a term for the unfamiliar. The anarchy of Dada can be balanced against the orderliness of Constructivism. In other words, keep the object of the exercise always in view, but remember that, in such typography, fashion may be a controlling feature. Fashion is a very real thing. It is something in the air, affecting clothes, furnishing, houses, motor cars and every kind of design.

If a designer today attempts art deco or art nouveau pastiche designs, in twenty years time they will look more like designs of the 1970s than either art deco or art nouveau. Victorian Gothic Revival churches do not look much like Gothic churches, they look like Victorian churches and in spite of that some of them are very beautiful. It is impossible to disregard fashion, fugitive though it may be.

3. The mechanics of typography

The primary job of the typographer is communication, though today the advertising world may ask rather more of him than this. Our job is fundamentally to communicate by typographic means. To do this we start with copy . . . words, an author's manuscript . . . a copywriter's scribble on a memo pad.

A typographic solution must lie in the sense of the copy – so read it. For the moment, let us forget the difficulties and limitations of book typography and concentrate on copy that can be encompassed by broadsheet or advertisement space. The form of any piece of typography must be dictated by the words. So, read the copy; digest it; understand it, then, within the area or the proportions of the advertisement or paper size, write it out. Do not worry about type forms. Just write it out, in pen or pencil or what ever comes easiest to you. I normally do my preliminary scribbles to a very small size in fountain pen. It is the content I am concerned with. The form can keep changing but not the sense. Once I have produced what I think is the most logical arrangement of my message, I will then write it out again very freely in a soft pencil to the right paper size. Only then will I start worrying about the sizes and the kinds of typefaces I want to use.

A lot of nonsense has been talked about the appropriate use of typefaces for certain kinds of job. I was once asked to design a type book on this principle. With loving care, I picked delicate, pretty little scripts for cosmetic advertisements, classical, formal and eminently respectable roman faces for banking houses and money lenders, black letter for church and law, big chunky sans for heavy engineering. It was only after I had designed about twenty of these examples that I found I could change their typefaces round at will and with ever increasing effect!

Limitations are an asset. In the days when all books were set in hot metal either by Monotype, Intertype or Linotype, and set by the printer who was going to print them, the typographer had to make do with one of the half dozen or so different typefaces that the printer carried. In the end, because of the needs of space or some other factor, the choice was probably whittled down to one or two faces, and the fact that 9 point

Plantin Light might take up fewer pages than its optical equivalent, say 10 point Baskerville, finally dictated the choice.

Today, in an age of film setting, as often as not the setting is carried out by a typesetting house with a bewildering choice of typefaces. The only useful suggestion I can make here is for the inexperienced typographer to concentrate on one or two typefaces, until by experience he knows exactly what they will do before branching out into other unknown quantities.

When laying out display lines, slip the typesheet under the roughly pencilled layout and match up, as near as you can, the size of type to the letters you have drawn, then rub these out and trace the types through. It is not very difficult. It is, however, worth taking great care, even infinite pains. A sensible practice is to decide on what size of type you think you will need, trace it through on to a narrow slip of paper and do this for each different line, then slip these under a clean sheet on which you have ruled out the paper and type areas. Juggle your lines about until they look right viewed through this top sheet, then retrace. *Never* try to save time pasting down these slips on top of your clean sheet. They never look right; the edges of the slips optically reduce the space between the lines, and when your layout is set, it is certain to look too open.

One rule of thumb is, when in doubt about what size to set either a display or text line, set it in a smaller size than you first think may be necessary. I don't know why this should be, but it works.

When representing areas of text setting, if the layout is going straight to the printer, it is enough to outline the area; if the layout is to be shown to a client, it is as well to indicate the tone of the type area. Do this by ruling in with a soft pencil double lines at the x-height of each line, or paste down some actual type matter, or use Letraset sheets.

One can learn the essentials of the subject in any design or printing school, but it is only by practice, by seeing one's layouts converted into printed matter that one becomes a typographer. One's mistakes are of priceless value for that is how one learns.

Grid for a series of art and design paperbacks
which were printed in Holland. It provided for
either one or two columns of text setting.

THE GRID
The grid is based on 'the repetitive rhythm of carefully
placed units'. This formal structure is a commonplace
with which any first year typography student will be
familiar. As the 'repetitive rhythm of carefully placed
units' is the essence of the grid structure, the grid
should be preceded by a miniature spread-by-spread
layout of the whole book or periodical. To this end a
sheet, such as that shown here, should be drawn out.
Any professional magazine or book designer would have
a large supply of such sheets printed for him. On these
miniature rectangles, the designer can then plan out his
book and so see at a glance the most constantly re-
curring factors, including the shapes and proportions of
the illustrations.

B.T.C.2038

Imposition sheet on which the layout of a book can be planned.

Then and only then should he attempt to draw out his grid, and even at that stage, it is advisable to lay out three or four spreads, including scaling the illustrations, to see how they fall in relationship to the text and the captions. The grid should not be a strait jacket, but it is a valuable structural support for the design.

METHOD OF WORKING

The essential factor in any typographic layout is the sense of the words. Once that has been established, there are other factors of equilibrium and tension. The traditional arrangements of perfect axial symmetry may still serve much typographic bookwork. The usual double-page spread, optically balanced, can still be the

Leading: a page from Horace Walpole's *The Castle of Otranto*, printed by Giambattista Bodoni at Parma in 1791. The large pica setting has a four point lead through the lines.

55

CHAPTER II.

MATILDA, who by *Hippolita*'s order had retired to her apartment, was ill-disposed to take any rest. The shocking fate of her brother had deeply affected her. She was surprized at not seeing *Isabella:* But the strange words which had fallen from her father, and his obscure menace to the Princess his wife, accompanied by the most furious behaviour, had filled her gentle mind with terror and alarm. She waited anxiously for the return of *Bianca*, a young damsel that attended her, whom she had sent to learn what was become of *Isabella. Bianca* soon appeared, and informed her mistress of what she had

most satisfactory layout for book pages. When, however, visual excitement is wanted, a rejection of such symmetry is almost a necessity.

In designing any piece of print which has more than one page, it is possible to build up a formal structure based on the position of the various elements that appear in different pages. For example, in the layout of a periodical, it is probably better to design from the inside to the outside; that is, first take a full text page and draw out the margins and the positions of the type, folios, etc., then add the position of a chapter or article opening. On those beginnings one can build up every likely permutation of illustration. This structure will now begin to look like the grid we have been talking about or at least a bit like a Mondrian painting. Into this grid one can now place any other element including details of contents, title-pages, covers etc. Horizontal structure may be more important than vertical, because of the way one's eye scans the page.

Jan Tschichold once said: 'simplicity of form is never poverty; it is a great virtue.' One doesn't have to try to be clever; if one really understands the sense of words the rest should follow. If the sense is understood, the typographic styling should be dictated by that sense, attempting only to elucidate, possibly to amplify, never to confuse the meaning. Experience is the only teacher. The sooner the young typographer can gain experience, the sooner he will know what he is doing, so it is better not to dissipate these early experiences.

It is far better to know one typeface well and even only one or two sizes of that face, than to have a dim appreciation of a number of different faces. So to begin with, work a face to death, so that you can find out just what it will and will not do in different sizes, under different circumstances and on different paper surfaces. No face is perfect for everything; certain sizes are better in one face than another. On the whole, large x-height faces like some of the Grotesques or Times New Roman are good in small sizes e.g., 6 point Univers 689 or 7 point Times New Roman. Small x-height letters with long ascenders and descenders are better in larger sizes e.g. 12 point Bembo or 14 point Pilgrim.

The essence of typography lies in interpreting with

clarity words, and so sense. To do this, there is clearly rather more to be considered than the choice of a particular typeface and its appropriate size. The first thing is the length of line. A readable line in a book may be of ten to twelve words. For approximate casting off, a word equals six characters. These six units include inter-word spaces and punctuation marks. An even more readable line is the normal column setting of a newspaper or journal, of from five to seven words.

As I have already said, one tends to read not by individual letters or even words, but by groups of words. Your tabloid newspaper line can be taken in at one glance. The line in a novel has to be followed through, and then the sense picked up in the next line. If your line is long, say eleven to thirteen words, it may be difficult to pick up the succeeding line. In this case increase your inter-line spacing by leading. Leads for hand setting are strips of metal 1 point, $1\frac{1}{2}$ points, 2 points or 3 points thick; for machine casting the equivalent one, two or three points are cast with the types, so making the body of the type deeper. For filmsetting, see page 109.

Too large a setting can be almost as unreadable as too small a setting and, for text matter, certainly far uglier because of the inevitable unevenness of spacing between words, unless the measure is increased to include a readable number of words, or the text is set unjustified.

LETTER SPACING IN MACHINE-SET HOT METAL
For letter spacing, hair spaces, thin, mid or thick spaces are replaced by units of which there are 18 to the em quad (that is the width of the capital M of what ever size and typeface you are using). So, for small capitals, you might say letter space by one or two units, to make the word that much more readable.

MEASUREMENT: SET AND UNIT OF SET
There has been some confusion among designers over the precise meaning of the word 'set', when applied to the Monotype keyboard and composing machine. In fact 'set' is the basic width of each particular fount, and the units of set, the width allocation of each letter. So, the

width of each individual character is designated as so many units of that fount's set.

The weakness of this system was revealed, with the development of the modern sophisticated film typesetter, which could carry a number of quite different founts, all with different sets and different units at the same time.

A new system has now been evolved, which still retains such advantages as the individual 18 unit system had. In the New Units System, the width of each character depends upon the New Units value and the point size. A New Unit is directly proportional to the point size being used. One New Unit at 12 point is exactly twice as wide as one at 6 point and so on.

The New Unit is one ninety-sixth part of the square quad (.0017292in for 12 points or .0008646in for 6 point). This can be applied to any point size to find the size of one New Unit. For wider or closer fitting of letters, the number of New Units can be increased or decreased to suit the designer's taste. The fine adjustments given by this 96 unit system can greatly improve the appearance of typesetting. This particularly applies to letters with an awkward fit such as the capitals A and W. In decreasing letter spacing, care should be taken not to overdo it, but some faces would certainly benefit. A face like Gill Bold would benefit by selective reduction of one or even two units. Likewise selective reduction could be applied to various italic founts such as Garamond with kerning letters.

ABCabcdefghijklmno pqrstuvwxyz

Gill Sans Bold, showing wide set. Typeface designed by Eric Gill in 1928.

Gill Sans Bold *and Italic* is available for keyboard composition

As the fount widths are no longer dependent on the old set factor, founts of quite different widths can be set together. The width of each New Unit for the American-British point system and for the Continental Didot point system is as follows:

POINT SYSTEM		DIDOT SYSTEM	
Point Focus	New Unit	Didot Focus	New Unit
5	.0007205	5D	.000770833
6	.0008646	6D	.000925
7	.0010087	7D	.001079166
8	.0011528	8D	.001233
9	.0012969	9D	.0013875
10	.001441	10D	.00154166
11	.001585	11D	.001695833
12	.0017292	12D	.00185
14	.0020174	14D	.00215833
16	.0023056	16D	.002466
18	.0025938	18D	.002775
20	.002882	20D	.0030833
22	.0031702	22D	.00339166
24	.0034584	24D	.0037

LEADING

The judicious use of leading is one of the great factors in successful typographic layout. Here one is handling white space, one of the key elements in typographic design, whether it is used for leading or margins or in any other way. As simplicity is the keynote of most successful design, so in typography the simpler the tonal contrasts in your black type, your grey areas of text setting or your white space, the better. Avoid a kind of pepper and salt mixture of these elements lest all tonal contrast be lost.

For display, particularly with grotesques or modern typefaces, the rule for leading formulated by G. B. Bodoni was to use one third of the body size. That is, for a twelve point setting, you would use a four point leading. This is far more open than one normally uses for book work and would certainly not have the approval of William Morris, who disapproved strongly of 'the modern practice of leading'. In fact, for old face types such as Bembo or Garamond that have long descenders, little leading is needed. Likewise, for short measures set in grotesques or other evenly weighted typefaces, the text usually looks better with little or no leading. If, however, one was setting in twelve point Monotype Bodoni 135 to a normal book measure, a four point leading would suit it perfectly. The strong contrasts and

vertical stress of this neo-classical face make it virtually unreadable unless it is leaded.

CASTING-OFF

When you have to handle more than a few lines of copy, which you can write out in type size, you have to assess very accurately, in the case of a book or a magazine article, or even a lengthy advertisement, exactly what space your printed text is going to occupy. The simplest method is to count the number of characters (including punctuation marks and inter-word spaces as characters) in an average line of manuscript, multiply this by the number of lines in a page and this figure by the number of pages in the complete manuscript. Then divide this figure by the number of characters in a specimen line of type set to the measure you propose to use. This will give you the number of printed lines. If they are too many, reduce the size of your setting, or increase your measure, or both. For accurate casting-off of relatively short pieces of copy, such as for press advertisements, it is essential to apply this procedure to each separate paragraph, and to count every character.

TYPE MEASUREMENT

For hand setting and type specifications one normally uses the American or Didot point systems, with the 12 point em being the unit for type measures.

All European printers, outside Great Britain, use the Didot point system. The Didot 12 point em is 1/16th larger than the American-English pica. (16 picas = 15 Didot ems).

In the Netherlands, the word 'aug' is used for a Didot 12 point em. This is used as an abbreviation for 'Augustinian Cicero'.

TYPE-RULE

This is usually a twelve inch steel or plastic rule with inches and eight point measure on one side and ten point and twelve point measures on the other. The normal unit of linear measurement in typography is the twelve point em (or pica). There are twelve points in an em and about six ems to an inch. Similar type rules can be bought with metric replacing the inch scale.

Layout for a title-page for the translation of *Le Grand Meaulnes*, drawn by Anthony Froshaug with type mark-up limited to essential factors. The careful drawing of the type matter and its very accurate positioning on the page obviated the need for further instructions. The actual printed title-page looked so exactly like Froshaug's layout, apart from a slight alteration to the copy in the bottom line, that it would be pointless to show it here.

Alain-Fournier Translated
by Françoise
Delisle

*8pt Bodoni u/lc
set solid*

The Wanderer . Le Grand Meaulnes Illustrated
by John
Minton
and with
an Introduction
by Bonamy
Dobrée

10pt Bodoni u/lc

Paul Elek Publishers Limited . London

10pt Bodoni u/lc

Layout by Anthony Froshaug for a page of
accounts drawn in red and black inks. 1946.

24 June 1946		**Balance Sheet**
		Properties (as valued by Messrs Farebrother, Ellis & Company at June 1937, or on subsequent completion, plus additions at cost)
	164 838	Freehold
	3 868 404	Leasehold (certain properties have suffered War Damage)
	42 000	Artesian Wells & Water Treatment Plant (as valued by Messrs Farebrother, Ellis & Company £49 000 less amount written off)
	4 913	Air Raid Shelters (at cost less recoveries)
	128 714	Property Suspense Account Balance (arising on Property completed and valued 1940)
	89 502	Contributions under the War Damage Acts Part I
	4 298 701	
		Mortgage Debenture Stocks
000 000		5% First
000 000		4% First
000 000		4½% First [1945]
000 000		5% 'B'
1 697 669		
1 343 835		Mortgages & Loans secured on specific properties
3 041 504		Total Loan Capital
78 026		Pre
	2 963 478	
	1 334 893	
	18 571	Leasehold Redemption Fund *deducted*
	1 316 322	
	6 567	Furniture, Fixtures etc
	48 000	Investments in Subsidiary Companies
	1 370 889	
		Current Assets
26 905		Cash at Bankers & on hand
20 000		Tax Reserve Certificates
63 523		Debtors
5 012		Amounts due from Subsidiary Companies
9 127		Stocks
7 527		Rates etc in advance
132 094		
		Current Liabilities & Provisions
20 762		Accrued Interest on Mortgage Debenture Stocks, Mortgages & Loans
96 481		Taxation on Revenue to date
68 727		Creditors, Specific Provisions & Accrued Expenses
69 148		Amounts due to Subsidiary Companies
94 353		Provision for Repairs, Decoration & Maintenance
349 471		
	217 377	**Excess of Current Liabilities & Provisions over Current Assets**
	1 153 512	**Net Balance representing Shareholdings**
		Capital fully paid
	500 000	
	100 000	
	400 775	
	1 000 775	
	152 737	**Revenue Account Balance**
	1 153 512	

26 October 1946

Report of the Auditors to the Members
We have audited the above Balance Sheet. We have obtained all the information & explanations we have required. In our opinion such Balance Sheet is properly drawn up so as to exhibit a true & correct view of the state of the Company's affairs according to the best of our information & the explanations given us and as shown by the books of the Company *H N Murray & Company*
Revenue House, 7/8 Poultry, London EC2 Chartered Accountants

Layout for specimen page for Dunlop Report and Accounts 1976. Proof printed in black and red of the Dunlop Report and Accounts 1976. The setting is in 8 point Univers Light, combined with 8 point Bold, which because of its large x-height, is very legible.

Consolidated Profit and Loss Account
Year ended 31 December 1975

Dunlop Holdings Limited

		1974		1973
SALES to outside customers		£888m		£750m
PROFITS	£000	£000	£000	£000
Balance from Trading		93,970		81,168
Less:				
Plant hire and lease rentals	5,291		4,748	
Depreciation	30,472	35,763	28,829	33,577
Operating Profit		58,207		47,591
Less:				
Rubber market losses		—		4,765
		58,207		42,826
Add:				
Government grants credit		1,811		1,662
Investment income		1,218		1,483
Proportion of Associated Companies' Profits		8,769		9,507
Profit before Interest and Taxation		70,005		55,478
Less:				
Financing charges		25,965		19,762
Profit before Taxation		44,040		35,716
Less:				
Taxation		24,433		19,552
Profit after Taxation		19,607		16,164
Less:				
Minority Shareholders' interests		9,506		6,312
Profit attributable to Dunlop Shareholders before extraordinary item		10,101		9,852
Add:				
Extraordinary item		917		—
Profit attributable to Dunlop Shareholders after extraordinary item		11,018		9,852
[Dealt with by the Company £5,437,000 (£4,186,000).]				
APPROPRIATIONS				
Dunlop Holdings Limited Dividends				
Preference		590		590
Ordinary: Interim	1,646		1,720	
Proposed Final	1,597		1,646	
		3,243		3,366
		3,833		3,956
Profits retained by				
The Company	1,604		230	
Subsidiaries	3,520		1,703	
Associated Companies	2,061		3,963	
		7,185		5,896
		11,018		9,852

Earnings (after tax) per ordinary share on total issued ordinary shares of £98.3 million are 9.68p per share (1973 9.42p), based on profit attributable to Dunlop Ordinary Shareholders, before extraordinary item, of £9,511,000.

22

LAYOUT PAD

This should be of good quality smooth Bank paper, transparent enough to see the letters on a type sheet clearly when this is slipped under a sheet of layout paper. An accurate, straight-sided drawing board, set squares and T-squares of good quality are of course necessary, as are hard and soft pencils and a soft rubber and type specimen sheets. Use a sharp H for 6 pt, a sharp HB for 12 pt and a sharp 2–4 B for display-size letters.

TYPE SPECIMENS

Without typesheets the typographer cannot usefully practice. The working typesheet should show every character in the fount and every point size. (Note: filmset sizes usually differ from hot metal sizes.)

Most typefounders and typesetters will supply specimen sheets but these are mainly for publicity purposes and do not show complete founts. The ideal working sheets are those published by the Monotype Corporation. For sheets such as these Alphabet Tracing Sheets one of course has to pay. These typesheets are an essential part of the stock-in-trade of any typographer.

When your layout is complete, mark it up outside the area in ink or coloured pencil, so that there is no confusion between what is to be set and what are the instructions. Put in the minimum amount of instructions, properly phrased. In printing, like any other trade, there is a language which one should follow. Even in a simple instruction for the setting of text in galley the typographer will word his instructions something like this: Set in 11/12 pt Walbaum series 374 to 24 ems.

11/12 pt means eleven point setting cast or filmset on a twelve point body, so including a one point lead. In short amounts of copy, for advertisement setting etc., it is more usual to mark the leading separately. Thus: 11 pt Walbaum 1 pt leaded. Walbaum is the name of a typeface; the series number is Monotype's designation for that particular face. A bolder version of Walbaum has a different series number. 24 ems is the width of the line equalling four inches.

The next thing you know, you have a proof in front of you and it bears no resemblance to what you intended!

Don't panic! Sit down and compare it very carefully with your layout. If it is a galley proof, trim it and mount it to exact size on your layout pad so that the ruled-in margins encompass it. The visual appearance of type changes markedly when this is done. The apparent size of a display line can alter in a quite marked manner if margins are reduced.

Check very carefully everything the printer has done, mark it up where he has not followed your copy; and mark it up where he has and it doesn't look right. When marking up proofs or manuscripts use the customary proof correction marks. These are a set of weird hieroglyphs. They are now published by the British Standards Institution, (Ref: BS 5261) and can also be found in various reference books.

In 1975 British Standards published their new edition of *Copy preparation and proof correction* with some interesting revisions to the marks normally used. These additions have been made in agreement with the International Organization for Standardization Technical Committee 130 on Graphic Technology.

These are the most used abbreviations:
caps – capitals, s.c. – small capitals, ital – italics
rom – roman, w.f. – wrong fount, trs – transpose
stet. – leave as printed (even if crossed out),
l.c. – lower case, u.c. – upper case
u and l.c. – upper and lower case.

PREPARATION OF MANUSCRIPT FOR THE PRINTER
When for the first time a pile of manuscript arrives on the typographer's desk, with a brief request to mark it up for the printer, he may well feel awed. This, like any other job, is a matter of experience. The procedure is as follows:

1. Check to see that the manuscript is in the correct order and that the pages are numbered.

2. Cast off, noting whether there are any lengthy quoted passages of text, which may well be set smaller or indented; also whether there are footnotes, which will certainly be set smaller than the text. Decide on type sizes, measures and number of words to the printed page.

3. Lay out specimen page spread, showing on the left the treatment of the chapter headings and on the right any subheadings or other peculiarities of the text. In the case of complicated, perhaps scientific texts, it will probably be necessary to have at least three pages set to cover all the text treatments.

4. Whilst specimen pages are being set, check manuscript inconsistencies in the use of capitals, etc., for literals, and mark up for any special differences of house style.

If the manuscript has been properly copy edited, the sub-editor will have dealt with details such as when and when not to use capitals. If the printer is an experienced book house, details of house style can be left to him, including methods of spelling, e.g. the use of 'z' or 's' in such words as realization (Oxford) and realisation (Cambridge), or colour (British) and color (American). If you are using a trade typesetter or a general jobbing printing house, leave nothing to chance. In a publishing house, much of this copy preparation should have been done by the editorial department, but if you are working for industry, it will probably be left to you. (See notes on house style in paragraph 7.)

5. Prepare copy for preliminary pages, including contents page, list of illustrations etc. This rarely comes with the manuscript. Any words to be set in italics mark with a single underline, those in small capitals with a double underline, those in capitals with three underlines and those in bold type with a wavy underline.

6. Notes can be placed at the foot of the page, set at least two points smaller than the text; or in the margins, if your margins are wide enough. In this case they need to be set even smaller. Or they can appear at the end of the chapter or at the end of the book. The simplest way of indicating them in the text is by way of superior figures. These are very small figures cast separately on the shoulder of the type. In the manuscript, indicate matter that is to be set smaller by a vertical line in the margin with the setting size indicated alongside.

7. Most publishers have their own house style. When working outside publishing, it is important that a typographer should follow a consistent style. Inconsistency in style looks slovenly and can even undo the

results of otherwise careful designing.

These are the essence of the Penguin rules, that Jan Tschichold formulated for Penguin Books:

All text composition close spaced (a middle space or thickness of letter i).

All punctuation marks followed by same space as is used throughout rest of the line.

Indent paras 1 em of point size. Omit indents in first line and under subheads.

Insert thin spaces before question marks, exclamation marks, colons and semi-colons.

Between initials and names (G.B.Shaw) and after all the abbreviations where a full point is used use a smaller space than between the other words in the line.

Marks of omission should consist of three full points, set without spaces but preceded and followed by a word space.

Use full points sparingly and omit after Mr, Dr, WC2, 8vo etc.

Use single quotes for a first quotation and double quotes for quotations within quotations.

Punctuation belonging to a quotation comes within the quotation marks, otherwise use outside.

When long extracts are set in a small type size, do not use quotes.

Use parentheses () for explanations and interpolations; [] brackets for notes.

Running headlines, unless otherwise stated, should consist of the title of the book on the left hand page and the contents of the chapter on the right.

Italics are to be used for emphasis for foreign words and phrases and for the titles of books, plays etc.

Figures in text matter, numbers under 100 should be words; use figures when the matter consists of a sequence of quantities etc. In dates use fewest possible figures set 1977–8 or 1979–80, dividing by an en dash.

Footnotes: set two points smaller than the text. Indent first line by 1 em of the *text* body matter and also lead as for the body matter.

Folios: set in text size in Arabic numerals. Pagination starts with the first page of the book, but folios first appear on verso of first page of text.

Plays: Names of characters should be set in capitals and small capitals. The text following is indented. Stage directions should be in italics enclosed in []. The headline should include the number of act and scene.

Poetry: use a smaller size of type than for prose. Lead and word space with middle spaces. Titles centre on measure,

and not on first line. The beginning of each poem may be treated as a chapter opening with small caps etc.

Indent first line of each verse.

Make up: Prelims 1. Half title 2. Frontispiece 3. Title-page 4. Imprint 5. Dedication 6. Acknowledgements 7. Contents 8. List of illustrations 9. List of abbreviations 10. Preface 11. Introduction 12. Errata

The text of the book beginning on a recto.

Additional matter Appendix, author's notes, glossary, bibliography, index.

Set all this matter in text size, except for the index which should be set two points smaller than the text. The first word of each letter of the alphabet should be set in capitals and small capitals.

The following additional notes on a personal house style are given here as minimal guide lines, and to amplify Tschichold's Penguin Rules.

QUOTATIONS Quotations of more than five lines should be indented and possibly set a type size smaller.

Quotes should fall outside a full point only when the quoted passage finishes with a complete sentence, e.g. He looked what Shakespeare would have called 'a motley fool', but as Macaulay said 'his imagination resembled the wings of an ostrich. It enabled him to run, though not to soar.'

Permission should always be obtained for quoting copy of more than 200 words, if it is still in copyright.

ITALICS OR QUOTES? Foreign words, titles of books, plays, etc. and names of ships should be italicised. Titles of poems, essays and articles should be put in single quotes.

HYPHENS. Omit where possible but use for compound adjectives and where there may be ambiguity.

ABBREVIATIONS. No full point where abbreviation is a contraction (ends with same letter as original word) but use a full point where abbreviation is truncated. Omit full points between letters or initials, such as BBC, NATO etc. Do not use inch (5″) or feet (7′) signs in text, but write 5in. or 7ft.

DATES. Dates should be set thus: 11 December 1912, for Great Britain and December 11 1912 for the United States. When referred to without year or month, set

thus: 'He arrived on the 5th.' Do not abbreviate to Jan., Feb., etc except in very tight situations. e.g. bibliographies. 55 BC but AD 1066.

NUMBERS. Spell out numbers up to one hundred, except where measurements are given, or where they are repeated, e.g. Fifty-five sheep, but 55 sheep, 62 lambs and 12 goats.

For quantities of money set up to one hundred for round figures, use abbreviations for odd figures. e.g. Thirty dollars but £47.30. When setting measurements, do not set thus: 10′ 5″ but 10ft 5in. For metric setting, set 127mm rather than 12.7cms.

BIBLIOGRAPHIES. Bibliographies should be arranged alphabetically according to author. Details should include publishers, place, date. If possible details of both UK and US editions should be listed: e.g. Lewis, John. *Anatomy of Printing*, Faber London 1970. Watson Guptill Publications New York 1970.

INDEX. The index is placed at the end of the book and is set in two or more columns to a page and at least two sizes smaller than the text setting. To separate out each alphabetical group, the first word of A, B, C, etc. can be set in capitals and small capitals unless the typeface, such as a sans serif has no small capitals, when it can be set in bold or have the same setting as the rest of the index, but have a double line space above it. Any words italicised in the text should be italicised in the index.

CAPTIONS. Captions should contain full details about objects or pictures described with their date. Also include the source or collection. e.g. Kurt Schwitters. *Bild mit Raumgewachsen.* 1920. Collage 969 × 980mm. *Marlborough Fine Arts.* Credits showing the gallery's, the lender's or the photographer's name should be underlined so that they will be set in italics. Indicate on the manuscript if you wish them to be set in a smaller size than the rest of the caption.

8. On anything else to do with methods of literary style, or spelling, consult Fowler's *Modern English Usage* (Oxford), *Authors' and Printers' Dictionary* by F. Howard Collins (Oxford) or the *Oxford English Dictionary* in one or other of its forms.

For American usage, consult *A Manual of Style, for Authors, Editors, and Copywriters* first published in 1906. 12th Edition 1969 published by the University of Chicago Press, Chicago and London. This compendious 546 page volume covers bookmaking, style, production and printing, including some useful notes on design and typography.

PREPARATION OF MANUSCRIPT FOR THE PRINTER

ℒ	delete	⋏	insert
#	space	⊙	insert a full point
☐	indent 1 em		
⌣	close up	,⋏	insert comma
?⋏	insert quotation mark		
	move line to right		
	move line to left		
	run on		

Proof correction marks.

4. The economics of typography and the new printing processes

The typographer has to concern himself with the economics of production. He should find out what are the limitations of his printer, or printers, and then work to the *limit* of those limitations. This is no bad thing. Limitations are a help rather than a hindrance, for they can help a designer to channel his efforts in one direction. For any kind of design for print, it is essential to know the maximum size of sheet that can be printed most economically for the job. In simple terms, this usually means that the more subdivisions you can get from your sheets, the less the machining cost per page will work out. In other words, if a book you are designing can be printed 32 pages to a sheet instead of 16 or 8, it will cost less per page. This does not mean that a typographer has slavishly to follow conventional book sizes, but that he has to work within the maximum limitations of paper or machine sizes.

It is also important to find out whether for the size of sheet you wish to use, your printer has only single colour or two-colour machines. If the latter, the advantage of a second colour or duo-tone printing of half-tones should be considered. The additional cost may not be very much.

There are various money-saving procedures, particularly in the reproduction of illustrations, which are rather outside the scope of this book. If half-tone or line subjects are grouped for the same reduction, you can save on reproduction charges. When you are working for offset and can work with sufficient precision to do the make-up, that is pasting-up reproduction type pulls and bromides of illustrations in the exact position for camera, you can save a lot of money. There may, however, be Union objections to this.

For typesetting that has to be done on the keyboard, either for filmsetting or hot metal, the fewer sizes you use, the cheaper the job will be. The scope, for example, of a Monotype matrix is not inconsiderable, for in hot metal it carries 225 characters (the enlarged matrix carries 255), and for filmsetting, from 400 to 597 characters and offers you not less than the following:

In roman: capital letters, small letters, small capitals, numerals, punctuation marks and ligatures.

In italics: capital letters, small letters, numerals, punctuation marks and ligatures.

In bold: capital letters, small letters, numerals, punctuation marks and ligatures.

Designing purely within the scope of, say, a 12 point fount, offers a challenge that is not difficult to meet, with the advantage that the type matter has a constant tonal value. Make-up is rarely done on the typesetter, for the keyboard operator is better employed setting copy. So, niceties of spacing, using only multiples of your text size, are irrelevant. The make-up is done on the stone or light-table and it does not matter, from the point of view of saving production costs, if you have asked for a 12 or 13 point space between each of the paragraphs.

In the imposition of books and periodicals, care should be taken in positioning illustrations that bleed. Check this point with your printer. Likewise in book work, where half-tone art paper illustrations are included in a book printed on antique paper, try to group these together so that a section of art paper can fall between sections of antique, or insert them as wraprounds, wrapping complete sections. Never try to insert wraps between, say, pages 1 and 2 and 14 and 15 of a 16-page section. The handwork involved in slitting the bolts is too costly.

The use of display typefaces not carried by your printer also involves extra cost, because in the case of hot metal setting he either has to hire matrices to cast the type and has to clear a case to house it, or he has to buy the type from a typefoundry or obtain type reproduction proofs from a typesetter. The latter are expensive. From these reproduction proofs, line blocks will have to be made.

FILMSETTING

Filmsetting is not exactly a new thing, for it was first patented nearly eighty years ago. In comparison with metal type, the photo-typesetter offers an unbelievable amount of freedom to the typographer. The typographer used to working for offset must have a fairly good idea of the potentialities of this two-dimensional typesetting.

When working for offset with a printer only equipped for hot metal setting, the make-up or layout man preparing copy for the camera assembles reproduction proofs, taken from normal type. This offers a fair amount of flexibility, for the inter-letter spacing of display type can be re-arranged. The only limit to what one can do is the limit of scissors and paste and the skill of one's fingers.

This same flexibility is carried into photo-typesetting but with certain advantages. An obvious one is the greater definition, for the printed letter is very much sharper than normal printed type or even than type pulled on baryta paper specially for reproduction processes. To some extent the actual thickness of the filmset letters can be controlled to suit differing paper surfaces.

Some of the filmsetters are calibrated on a point system, others work to a metric scale. This is of no little importance to the designer for he has almost unlimited flexibility in letter size, in leading and spacing. This means he can set in $14\frac{1}{2}$ point with $\frac{1}{4}$ point leading if he so wishes. With an accurate lay-out the bulk of the make-up can be done on the filmsetter. As a result, instead of having to assemble a number of separate strips of letters, a whole page can be exposed on one piece of film. The availability of typefaces varies from one typesetting house to another. In theory it would seem that any typeface that is cast in hot metal could be used for photo-typesetting.

A very real advantage of photo-typesetting is that sizes up to 24 point (14 point is the normal hot metal maximum for Monotype keyboard setting) can be set as easily as small text sizes. The advantages of this method for children's books hardly needs emphasising.

LAYOUTS FOR FILMSETTING
It is possible to prepare two kinds of layout for film-setting. The first kind is the 'visual' layout where the matter to be set is represented by drawn characters in the case of displayed pages, and by type areas in the case of text pages. These are used when make-up is done manually on a make-up table, and should be drawn on stable translucent paper in order that the make-up compositor can work over them.

VIP Input sheet: the instruction letters following
the line numbers are typed in red.

```
6 s,
7 xgsb,Sheet 1: The aristocracysr,
                                                         1
8 g    What qualities did Squire Brown hope that his son would have drummed into him at public school?
9 g    Explain in your own words the ''caprice'' of Matilda and John, as described by the Governess insi, Agnes
0 Grey.sb,
1
2 Sheet 2: The middle classessr,
3 g    To what things do you think the writer in si,Punchsr, was referring when he spoke of ''provisions for the
4 corporal and mental nutrition'' for pupils in cheap Yorkshire schools?
5 g    Give the correct spellings of ''winder'' and ''bottiney'', and explain what ''quadruped'' really means.
6 g    What does each of the advertisements say about holidays for the pupils, and what do you think is the
7 significance of this?
8 g    To what extent do you think the description of these schools is a true picture of education at this time?
9 Why might there be exaggerations?sb,
0
```

With the introduction of unjustified setting many more decisions are made by the computer or on VDU screens, and for this type of make-up layouts which are not visuals, but which convey written instructions to the keyboard operator are much more useful, as they eliminate lengthy delays at the keyboard while the operator has to measure (with a type rule) the distance between two lines on a visual.

In order that these layouts can be prepared correctly it is necessary to understand how a filmsetter works, and what its parameters are (range of point sizes, basic increments of white space in depth composition, letter-spacing facilities, etc.).

FILM FEED
All text filmsetters use the same method of providing the constant distance between one line of text and the next. The line is composed horizontally and justified, and the justification signal (in the paper tape in justified

composition, and generated from the computer in un-justified composition) is also the signal for the film to be drawn forward a specified distance so that the next line is composed in the film area immediately following that used for the previously-exposed line. The correct term for describing this distance is 'film feed', which can be abbreviated to FF or ff followed by the distance, thus ff12 would represent a distance *from baseline to baseline* of 12 points. All depth measurements in film-setting are made from baseline to baseline as the exposed character has no body to form automatic datum points, and its relation to the character below and above is decided solely by the movement of the film. Film is generally loaded in rolls of 50 or 100 ft, although the Monophoto 400/8 filmsetter provides an alternative drive which uses sheet film in galley lengths with a maximum of 24 in length. The unit by which film feeds are incremented varies from machine to machine. The commonest increment is $\frac{1}{2}$ pt, although some machines have an increment of $\frac{1}{4}$ pt, and others work only in whole points.

Equally, the largest amount that can be fed at one operation varies. The Monophoto 400/8 and the Linotype VIP filmsetters both have a maximum of $99\frac{1}{2}$ pts film feed in $\frac{1}{2}$ pt steps, but the Photon Pacesetter series has a maximum of $127\frac{1}{2}$ pts by $\frac{1}{2}$ pt steps. The space can thus be increased between paras, under headlines and over folios by any number of $\frac{1}{2}$ or 1 point increments. Most filmsetters provide a secondary depth spacing system known either as 'leading' or 'additional leading'. This is used for inserting space *additional to that provided by the line feed signal*. It can be simply marked on layouts by showing it as '3 pt' or '3'. Additional leading generally has the same maximum and the same incremental steps as the film feed.

When marking up displayed matter for filmsetting the page should begin with a horizontal register mark followed by a film feed of the quantity required to the base of the first line of copy. This provides for the height of the first line of type, which will vary according to the size used. Each successive line should then indicate the distance to the next baseline, and the last line should be followed by a further register mark. The

The measurement of a typeface, the x-height base line is the 'base line' referred to in the text.

total of film feeds – line feeds and additional leading – should equal the total distance between the two register marks. Thus an 8in advertisement setting would equal 576 points, and the feed between the top register mark and the height of the first line would form the white at the head, while that between the baseline and the last register mark would equal the white space at the tail. The total of film feeds between the first register mark and the feed after the last line should equal 576.

WIDOW LINES

In filmsetting it is almost impossible to define where 'widows' will occur when copy marking or setting at the keyboard. Some sophisticated computer programs do provide means of determining this, but in general these lines are found and eradicated at the stage between first setting and make-up, or between the first pass and the second pass on the filmsetter when a two-pass system is used. The editorial use of VDU screens and Line Printer print-outs will eliminate these before filmsetting takes place, but if the method used to avoid 'widows' is by copy editing then the printer himself will be unable to do it, and many customers are averse to reading computer print-outs.

In manual make-up systems they may be eliminated by the author editing them out in the galley proofs, by the introduction of discreet paragraph leading, or by letting a pair of facing pages go a line short or a line long. In filmsetting machines which have a filmfeed increment of $\frac{1}{4}$ pt it is possible to lose a 'widow' line by reducing the film feed by $\frac{1}{4}$ pt for the number of lines necessary to save a line. Some earlier Monophoto machines were specially made with this smaller increment, but the provision of these has now been discontinued and this method is no longer available from Monophoto.

UNIT ADDITION AND SUBTRACTION

A much-improved system of dealing with 'widows' has now been evolved by the substitution of a 96-unit quad on the Monophoto 400/8 for the conventional 18-unit quad. Unit reduction and addition in increments of one unit (1/96 of the em quad) are almost invisible to the reader's eye even when used up to 3 units (less than half of the previous unit) and it is generally possible

to find a paragraph where either addition or reduction will make or lose a line.

The necessary signal is put into the paper tape at the point where addition or reduction is to begin, and a cancel signal is inserted at the point where it is to end. The use of this facility on whole chapters will often allow the editor to eliminate a chapter end which has a very few lines on the last page, or to increase it to an acceptable number of lines.

The same facilities also allow a new standard of visual letterspacing in display lines which can have the amounts between each pair of letters marked in varying quantities of letterspacing. The keyboard operator has the ability to insert any number of units between the letters. Care should be taken when marking up letter-spacing to indicate that the units are new units (1/96) or old units (1/18). If old units are indicated the operator can convert them, but it is well worth the effort to start thinking in terms of a 96-unit quad when marking up for Monophoto 400/8 setting.

MAXIMUM MEASURES

The maximum measure of a line varies considerably between one machine and the next. Some machines being geared for whole-page newspaper composition offer a 100-pica maximum, while others cannot accommodate lines longer than 36 picas. The standard measure on all Monophoto filmsetters is 54 picas set on a maximum film width of 10 in. or 250 mm.

PI CHARACTERS

The provision of a 'pi' character facility (a 'pi' character is an outside or extraneous sort which is not contained in the standard matrix-case layout) also varies according to the filmsetter used. Some filmsetters using filmstrips or discs have no facility at all, while others have secondary strips or grids to provide these sorts.

The mechanical Monophoto machines Mk 1 to Mk 5, and Monophoto 400/31 and 400/8 all have completely interchangeable matrix-cases, and pi sorts can be included by substitution for other characters not required. The Monophoto 600 filmsetter has 100 special slides each of which holds two character images which are readily interchangeable and can, indeed, be made by the printer himself.

Normal unit values

The first thing to remember about a filmsetter is that it is a camera and that its function is to present language in all its beauty, variety and intricacy. Its products are more versatile than those of casting machines, and they open up to the typographer a whole new vista of design, liberating him **The first thing to remember about a filmsetter is that it is a camera and that its function is to present language in all its beauty, variety and intricacy. Its products are more versatile than those of casting machines, and they**

Two-unit reduction

The first thing to remember about a filmsetter is that it is a camera and that its function is to present language in all its beauty, variety and intricacy. Its products are more versatile than those of casting machines, and they open up to the typographer a whole new vista of design, liberating him **The first thing to remember about a filmsetter is that it is a camera and that its function is to present language in all its beauty, variety and intricacy. Its products are more versatile than those of casting machines, and they**

Three-unit reduction

The first thing to remember about a filmsetter is that it is a camera and that its function is to present language in all its beauty, variety and intricacy. Its products are more versatile than those of casting machines, and they open up to the typographer a whole new vista of design, liberating him **The first thing to remember about a filmsetter is that it is a camera and that its function is to present language in all its beauty, variety and intricacy. Its products are more versatile than those of casting machines, and they**

Four-unit reduction

The first thing to remember about a filmsetter is that it is a camera and that its function is to present language in all its beauty, variety and intricacy. Its products are more versatile than those of casting machines, and they open up to the typographer a whole new vista of design, liberating him **The first thing to remember about a filmsetter is that it is a camera and that its function is to present language in all its beauty, variety and intricacy. Its products are more versatile than those of casting machines, and they**

The effect of Monofilm unit reduction shown in text settings of Apollo.

THE OUTPUT MEDIUM

If buying trade filmsetting for use by another printer it is necessary to specify what form the finished product must take. There are three possible products from the filmsetter: photographic paper positives, direct-reading film and reverse-reading film. Whichever is produced is dependent upon the capabilities of the filmsetter and the use to which the product is to be put. In addition many trade setting houses will provide direct-reading or reverse-reading negatives copied from the product of the filmsetter. When photographic paper (the cheapest output in material terms) is used; proofs will be electrostatic from one of the many copiers now available. If

Normal unit values

THE FIRST THING TO REMEMBER ABOUT A FILMSETTER IS THAT IT
The first thing to remember about a filmsetter is that it is a

Two-unit reduction

THE FIRST THING TO REMEMBER ABOUT A FILMSETTER IS THAT IT
The first thing to remember about a filmsetter is that it is a

Three-unit reduction

THE FIRST THING TO REMEMBER ABOUT A FILMSETTER IS THAT IT
The first thing to remember about a filmsetter is that it is a

Four-unit reduction

THE FIRST THING TO REMEMBER ABOUT A FILMSETTER IS THAT IT
The first thing to remember about a filmsetter is that it is a

The effect of Monofilm unit reduction shown in
display settings of Apollo.

film is used dyeline proofs made by a diazo process
will be provided. The latter are of much better quality
than the electrostatic proofs. If a quantity of proofs is
needed, inexpensive paper plates are made and printed
proofs are produced from it.

From the foregoing brief remarks it will be seen that
one of the essentials for successful layout for filmsetting
is a clear knowledge of the capabilities of the machine
to be used. Where a manuscript is prepared before
estimates are asked for, it will be necessary to have a
second look at it when the machine to be used by the
printer is known.

CASTING-OFF COPY FOR FILMSETTING

The basis of all good casting-off is the care taken with the character count applied to the manuscript. An assumption that the first few pages of a manuscript which average x number of lines per page and y number of characters per line, will, when multiplied by the number of pages in the manuscript, represent the total characters in the book is a dangerous over-simplification.

Changes in the typing format, short pages at chapter ends, written inserts and deletions, all will alter the basic count. The most successful way of casting-off the manuscript for a book is to treat the copy chapter by chapter. If each chapter is to begin on a separate page this will give a fairly wide margin of error, and will also provide a much more accurate picture of the whole format of the book.

With a line depth gauge and a width gauge made to indicate the number of characters per line of the typewriter used (most typewriters type 10 or 12 characters to the inch) it is possible to run quickly through each chapter. The new, cheap, electronic calculators are now virtually a must for any typographer.

The other factor which will seriously affect the count is the frequency of paragraph ends. Remember that each time a paragraph end occurs the set line will only hold an average of half the number of characters in a full line. Books with a great deal of dialogue need almost single-line counts in areas where a long conversation is to be set.

If when casting-off, you have a clear idea of the typeface and size to be used, then it is possible to do a much more accurate cast-off. If the measure of the typed line is reasonably near to the number of characters in the set line, then all paragraph end lines in the copy should be counted as being full lines. This will balance the short line at the end of each set paragraph. Where there is a wide difference in the two counts it is necessary to determine the frequency of paragraphs and to adjust the casting-off figure of set characters per line to allow for the short line. Whenever possible, when casting-off, avoid the counting of characters in short lines in the manuscript and deal with them as full lines, and then to counteract this by the calculation of the set matter.

When casting-off for short pieces of matter such as a blurb on a book jacket, or short pieces of solid text in catalogues or advertisements, the only acceptable way is to count paragraph by paragraph. Then determine a scale of multiples of the number of characters in the set lines (1 = 42, 2 = 84 *et seq.*) and compare the two figures. As each paragraph will contain a short line this gives a wide margin of error and only seldom will a question arise as to whether it will or will not make an extra line. This can be decided by looking at the frequency of capitals or wide or narrow letters in the paragraph concerned. The writer makes a habit of marking the forecast number of lines on the copy, and comparing them with the finished proof. This gives a continuous check on the efficacy of the copy-fitting tables.

COPY-FITTING TABLES

Most typesetting machine manufacturers supply copy fitting tables for their typefaces, although it must be admitted that the Monotype Corporation have always taken a great deal more care in supplying their customers – and their printers' customers – with information of this kind. It must be emphasised that the accuracy of these figures is the second most important factor in doing a good cast-off, and that wide variations occur in the care taken by manufacturers in compiling their figures.

The standard work is Monotype's *Scientific Copyfitting* which gives a cast-off system based on a wide analysis of character frequencies in English printing. The operative word is 'English'. The figures in their tables are not suitable for settings in foreign languages because the incidence of the use of various letters is not the same as in English. The basic system can be applied to foreign languages but it is necessary to have a table of frequencies for the language concerned and to understand how the factor is calculated.

The actual cast-off calculation is very simply set out:

$$\frac{\text{Number of characters in manuscript}}{\text{Number of set characters per line}}$$

$$= \text{Number of lines}$$

Then

$$\frac{\text{Page depth}}{\text{Line feed}} = \text{lines per page}$$

$$\frac{\text{Number of lines}}{\text{Lines per page}} = \text{Pages in book}$$

When looking at these calculations it will be readily seen how a chapter-by-chapter calculation gives a much more accurate count of the pages in a book. This takes account of the drop-heading at the commencement of each chapter, and also the short page at the end. It is even possible to run one chapter into the next when chapters do not begin on new pages.

Remember particularly that character counts for hot-metal setting do not apply to filmsetting. In hot-metal setting each size of type is individually cut, and the set size relationship to the point size differs for each size. In filmsetting different sizes are obtained by magnification, and the relationship between set size and point size remains constant. Monotype provide separate tables for metal setting and filmsetting. The introduction of the 96-unit system on their 400/8 filmsetter has necessitated a complete revision of the casting-off tables, and a new edition of these is in preparation.

Remember too, that the name of the typeface is no guarantee that it will have the same character count as its namesake made by another machine manufacturer. Baskerville, Plantin, Univers and Times are produced by a number of manufacturers. In some cases the name is the only similarity, the actual characters are vastly different in design and proportion.

Type size ranges, fount availability, size and fount mixing: every filmsetter has different capabilities in this direction, and manufacturers often market a number of models which extend the availability of them. It is impossible to set out all the variations and readers should write to manufacturers and collect the specifications for themselves.

Type sizes vary in the range, from 4 point to 72 point and from only the basic text sizes to the whole range. The most humble machine may only offer two 90-character founts of roman and italic or roman and bold,

while it is impossible to quantify the founts available on a digital-character CRT filmsetter which builds its own characters and creates italics, bold and condensed versions from distortions of the master character.

A typical example of a text-and-display setting machine is the Monophoto 400/8. It provides 16 sizes from 5 point to 24 point, including $5\frac{1}{2}$, $6\frac{1}{2}$, $7\frac{1}{2}$, $8\frac{1}{2}$, and $9\frac{1}{2}$ point if required. The range is decided by the printer within the limits stated. There are 400 matrices in the matrix case, and these are basically divided into four founts of 96 characters each, with 24 positions for use for pi sorts, or for accented characters for foreign language settings, etc. The founts need not necessarily be all of the same family, and the user is free to mix any four founts which may be chosen for a particular setting.

All founts, in all sizes, may be freely mixed within a line. The number of characters available is augmented by the fact that superior letters and characters may be produced as inferiors by altering the base line alignment. The degree of alteration is in 5° steps from 5° to 60° and two steps are available at any one time. The average running speed of the machine is approximately 40,000 characters per hour and there are facilities for corrections to be made on the run by the use of a correction tape on a separate reader.

TYPESETTING FOR ADVERTISEMENTS

The Diatype and Diatronic machines, which are both manufactured by the Berthold Typefoundry in Germany, are widely used by trade typesetters for advertisement setting.

The Diatype carries its typefounts on a revolving disc. It gives a very good image and can set any typesize from 5 point to 36 point. Its only disadvantage is that it cannot easily justify lines of type to an even measure. Except for that limitation, it can make up advertisements ready for press.

For more sophisticated setting, where mixed typefounts may be needed, trade setters usually use a Diatronic machine. This is controlled by a computer with a simple ring-core memory. It can set a mix of eight different typefaces at the same time. The Diatronic can set fifteen different standard typesizes from a range

of about 180 different typefaces. Settings can be justified and all European accents are included in the founts. It can also do complex ruling both vertical and horizontal in weights ranging from 0.33 point up to 7 point.

The Diatype and the Diatronic machines set both line length and film feed in points and millimetres respectively. They convert by means of a table from Anglo-American or Didot point systems to metric. Neither of these machines takes the place of the normal hot metal or filmsetting systems used for periodical and book printers. They are however a real asset to designers working on either display or tabular work.

THE IBM SELECTRIC COMPOSER

This type of IBM machine is used both for office printing and in academic establishments. The quality of the work, in comparison with normal typesetting machines, depends entirely on the abilities of the operator and the adjustment of the machine. Careless typing and ill-adjusted machines can produce abysmal results. When the machine is properly adjusted (this can affect the letterspacing), and is used by a skilful operator, and the platemaking and printing are well done, it would take an expert to tell whether some copy set, say in IBM Journal Roman, was not the product of a Linotype or Monotype machine.

The IBM Selectric Composer is a development of the IBM Selectric Typewriter, where in place of the traditional bars that carry the individual letters, the whole type fount is carried on a 'golf ball' that moves back and forth across the page. The fount can be changed at will and with ease, merely by pulling the fount lock lever up and then lifting the ball off the machine.

The copy for reproduction is typed onto baryta paper using a plastic reprographic or carbon acetate ribbon. Copy can be justified effectively, but it first has to be set unjustified and then, after taking a reading on the justification tube and setting the reading on the justification dial, retyped. As one of the objectives of using the IBM machine is economy, it is debatable if justification is justified! However, the more modern machines will justify automatically.

Type sizes from 6 point to 12 point can be set to a maximum measure of 36 ems. The designer should be

aware of one or two points. For instance, the left hand margin should be set, wherever possible, on a whole pica (12 pt) marking, i.e. working on a precise multiple of picas for the margin. The right hand margin however can end on a half-pica marking. Copy can be set with an uneven margin on the left and a straight margin on the right. This is done by the simple expedient of first typing the copy, ranging from the left margin and filling out the line with lower case 'm's. If there is a space of less than an 'm' width left, count the remaining units needed to fill the line. Then retype the same number of 'm's and units from the left margin (with the no-print key depressed) and finally type the copy. This is repeated for each line.

Leading is in 1, 2, 3, or 4 point units or multiples of four, i.e. not 5, 6, or 7. When indenting paragraphs, make the indent in picas, not in $1\frac{1}{4}$, $2\frac{1}{2}$ picas etc. Inter-word spacing is normally 3 units, which is one touch of the space bar.

There are certain typographic difficulties such as the lack of small capitals in founts like Press or Journal Roman. For instance, in composing an academic staff list for a university calendar, the operator is faced with the problem of setting the degrees that follow the tutor's names. These can be set in either text sized capitals, which look clumsy and take up too much room, or they can be set in the capitals of a smaller point size. This means changing the 'golf ball' two or three times for each name – a daunting job, but in fact the only satisfactory solution.

The comparison here of an IBM setting with a Monotype setting shows how well it can compete, if in competent hands.

A comparison of copy from the University of Essex Calendar which is now set on an IBM 72 Typesetter (to the left) and was formerly set on a Monotype machine and cast from hot metal (to the right). The main problem in the IBM setting was the lack of small capitals used for the degrees. This involved a change of fount in each line.

Library Staff

Librarian	P. Long, M.A. Oxon.
Sub-Librarians	D.B. Butler, M.A. Oxon.
	M.J. Sommerlad, M.A., D.PHIL. Oxon.
Assistant Librarians	A.J. Baines, B.A. Keele
	L. Hallewell, B.A. Lond., F.L.A.
	G.S. Kuphal, B.A. Birm.
	W.R.C. Longley, B.A. Camb.

Library Staff

Librarian	P. Long, M.A. Oxon.
Sub-Librarians	D. B. Butler, M.A. Oxon.
	M. J. Sommerlad, M.A., D.PHIL. Oxon.
Assistant Librarians	L. Hallewell, B.A. Lond.
	G. S. Kuphal, B.A. Birm.
	B. S. H. Rees, B.A. Wales
	B. J. C. Wintour, M.A. Camb.

COMPUTERISED SETTING WITH THE IBM MAGNETIC TAPE SELECTRIC COMPOSER

A computer is only an adding machine with a greatly expanded memory. In typesetting, it can be programmed to do a number of things. One of the most obvious is to make end-of-line decisions of when, where and how to break words. This can apply to either justified or unjustified setting. This leaves the keyboard operator free to type as fast and as accurately as he can.

The simplest form of computerised typesetting is the IBM Magnetic Tape Selectric Composer system. For this the operator types on an 'input' typewriter, but as he types, the letters are also stored on a magnetic tape. His actual typed sheet is referred to as the record copy. Corrections are made to the tape either by back spacing and overtyping, or, if they are made at a later stage, by typing the corrections on a separate tape which can be made to merge with the first tape.

This tape is fed into a computer which has been programmed to justify, merge the corrections and arrange the text. At the same time the computer drives the 'output' Magnetic Tape Selectric Composer, with the typical IBM printing type fount-carrying 'golfball', which produces the text, now set in the required fount of type, on film or paper. This is now ready for photographing or plate making.

The operator has a group of control codes, for positioning, justifying, indenting etc. These he types in red in the input typewriter. As far as the typographer is concerned, the planning must take account of the limitations of this system. Careful copy preparation bearing in mind just what this system can do is essential. The code marking of the copy should be left to the printer.

LINOTYPE VIP

The next development up from the IBM MT/SC is Linotype-Paul's VIP (an American-designed machine) which is coming into use with printers. It is a relatively inexpensive machine, fitted with a small 6 (K = 1000) word computer. The input copy in this computer has to control the VIP in real time, which is twenty-five times the caster speed, as well as carrying out the various typesetting functions that any photosetter has to

120

do. And it has to hyphenate. The programming of an adequate number of word breaks for the English language is no easy thing, but the VIP seems to manage it very well. Its algorithm for hyphenation (i.e. its sequence of instructions) is limited by the number of other instructions, for instance instructions to the camera lens, the shutter and the master film strip, which it has to carry.

A Visual Display Unit (VDU) can be linked to this system and can be used for instant word or line correction. The time saving possibilities of the VDU cannot be over estimated.

AUTHOR'S CORRECTIONS

Author's corrections in hot metal are time-wasting, usually unnecessary or the result of incompetence and are inevitably costly. They are even more time-wasting and costly in photo-typesetting. It is important to send 'clean' copy to the printer, and layouts should be accurate – really accurate.

DISPLAY TYPESETTING

Until the 1960's most advertisements were set by trade typesetters from metal type, with the limitations that that implies. Today, most advertisements and many headlines used in publishing are filmset. Innumerable alphabets have been photographed on to reels of 51 mm wide film. These reels are exposed in a machine called a Typositor (manufactured by Visual Graphics Inc.). This machine can vary the size of the letters and can distort, expand or condense them. Letterspacing is visually controlled by the operator. The photoprints from this machine are then imposed on low tack paper from which they can be lifted with ease. This artwork is then ready for camera.

Display lines can be distorted in all manner of ways by the use of different lenses. The term 'Modigraphic' is used for this camera distortion, which can not only produce curved and wavy lines of type but also complete circles of type. This is produced by the camera from a simple straight line of type.

The possibilities of type distortion by these means seem to be infinite, but the success of much of this work does depend on the skill and the imagination of the operator.

ABRAMESQUE
Absalom
Accent
Achen Bold
Action
Ad-Contour
Ad Lib
Ad Lib Italic
Adonis
Advertiser's Gothic Light
Advertisers Gothic
Advertisers Gothic Cond
Aegean
AESTHETIC INITIAL
AESTHETIC ORNAMENTED
AETERNA
AETNA
Agate Script
AGENCY GOTHIC OPEN
Aggie Solid
Albertus Light
Albertus
Albertus Bold
Alfereta
ALFIE SOLID
ALFIE OUTLINE
Algoaqaia Shaded
Allegro Flare

TALBOT ROCKY MOUNTAIN
TALBOT OUTLINE
Tally
Tangier
TANGLEWOOD CAPS
Tannenberg
Tasman Light
Tasman Medium
Tasman Bold
TEACHEST
TELSTAR
Tempo Black
Tempo Black Cond
Tempo Heavy Cond
Tenor
Texan
Texture
Thalia
Thorowgood
Thorowgood Italic
Thorowgood Italic Swash
THORNE SHADED
THUNDERBIRD
THUNDERBIRD EXTRA CONDENSED
TIDAL
Tiffany Light
Tiffany Medium
Tiffany Heavy

The range of typefaces carried by typesetters for use on the Typositor is almost unlimited. This is a selection from something like 2,500 different typefaces carried on film by the London firm of Conways Photosetting.

abcdefghijk normal
abcdefghijk 5% condense
abcdefghijk 10%
abcdefghijk 15%
abcdefghijk 20%
abcdefghijk 25%
abcdefghijk 30%
abcdefghijk 35%
abcdefghijk 40%
abcdefghijk 45%
abcdefghijk 50%

abcdefghijk normal
abcdefghijk 5% expand
abcdefghijk 10%
abcdefghijk 25%
abcdefghijk 50%
abcdefghijk 75%
abcdefghijk 100%

Some of the possibilities for type distortion by means of the Modigraphic System used by Conways Photosetting.

5. Notes on typographic styling

EMPHASIS

Originally, printers used roman, in contrast to the black letter in use for normal text setting, for emphasis. Today there is a growing tendency to use a bold face and sometimes a face unrelated to the text type; for example, in a setting in an old style typeface the use of a bold sans serif. There are subtler ways of achieving this contrast, such as the use of a lighter than usual text type (such as Univers Light Series 685 with a medium weight type for the bold (Univers Medium Series 689). Emphasis in text can also be achieved by the use of italics, small capitals and on occasions by underlining. This tends to be effective in large sizes (above 30 pt), but if one is using cast metal type it may be necessary to trim the beard of the type, to bring the underlining close to the body line.

HEADLINES

The larger the size of type you are using, the lighter it can be; conversely the smaller the heading, the bolder it needs to be. If you are using a second colour, always use a bolder face than you would if you were using black only. For close setting of lines in capital letters, use titling capitals which have no beard, so the foot of one letter can virtually rest on the heads of the letters in the line below. In a series of lines of displayed copy, the sudden change from lower case to capitals for a single line can be effective. Lines in capital letters tend to look lighter than those in lower case.

SUBHEADINGS

These can be set in body type, in small capitals or in a related or a contrasting bold typeface. If the subhead is leaded, always have more space above than below e.g. If the text is set on a 12 point body, 3 points could separate the subhead from its relevant text and 9 points separate from the preceding paragraph.

NUMERALS

There are two styles of numeral called old style, 1234567890 and modern 1234567890. In text sizes (i.e. 14 point and under, or 24 pt and under for filmsetting) the old style numerals will line up optically with lower case letters and small capitals. The modern numerals will only line up with capitals. For display in larger sizes,

the modern lining numerals are usually more effective. For copy with much figure work such as company reports etc., use lining numerals. Sans serif types have these modern (capital letter ranging) numerals. On occasions, such as when designing letterheads where there are a lot of numerals and capitals, for post codes etc., it may be advisable to drop down a type size.

SPACING

The careful use of word-spacing, letter-spacing and punctuation marks can make a great difference to the appearance of the copy. Type matter for most book and periodical work is set justified, that is, with a straight edge down each side of the type matter. With lines of sixty or more characters, it is not difficult to set justified copy with visually balanced inter-word spacing. The normal inter-word spacing in any good Monotype house is 3 or 4 units. There is a long tradition behind this manner of close setting. It dates back to before printing began, when any scribe in a mediaeval monastery would ensure the evenness of his copy by his close spacing. To achieve this, he would resort to every kind of contraction and ligature. The printer's resources of contractions and ligatures are rather more limited but he can make use of some; he can also have a certain number of broken words at the end of a line, though he should avoid having broken words in more than two successive lines. The method of breaking words in appropriate places is discussed at length in the Oxford University Press's *Rules for Compositors and Readers*. The use of the ampersand '&' in the place of the word 'and' is just one permissible contraction to save a little space. Æ, Œ, fi, ff, fl, ffi, ffl are some of the ligatures in normal use.

LETTER SPACING IN DISPLAY

Any serifed capital letters larger than 8 point look better with letter spacing, with the exception of condensed capitals, which are designed as space-savers and if spaced at all widely, not only lose their purpose but also tend to look like a row of fencing posts and become almost unreadable.

A rule of thumb for letter spacing capitals is that the space between the capitals should be between one fifth and one sixth of the point size, but, particularly in large

Hly rcmnd for bsnsmn. 3000 to 90,000 sq. ft. mod factories to let with office acco-mdn. Rm to expand. Plus 1 - 21 fully serv'cd acres. Ex-lt. communications road, rail, sea, air. Ring Skelmersdale 24242 STD Code (0695) Telex 628259

The use of abbreviations in advertisement setting and the effective use of the typewriter.

sizes, the optical space between the letters must be made to balance. This is about the same as the space between the verticals of a capital letter H of the fount. Letters must be visually, not mechanically spaced. Never letter space, or word space for that matter, to more than the space between the lines.

When displaying capital letters, where more than one line has to line up vertically with another, the letters A C G J O Q S T V W X Y should be lined up optically; that is, they should over-run the measure. The most difficult capital letter to begin or end a line with is T with its over-hanging cross bar. The word 'THE' is one of the most difficult words to space and position. A more even effect can be achieved if certain marks such as hyphens, full points, commas and quotes are also thrown out beyond the measure. There is nothing revolutionary about this. Gutenberg, following the practice of the scribes exceeded his type measure in this way in his 42-line Bible. It is better to keep exclamation marks and interrogation marks, colons and semicolons within the type area as these are of a similar weight to normal lower case letters. Certain founts of type suffer from defects such as having over-heavy punctuation marks. It may be worth while on some occasions substituting punctuation marks from a different fount, where they are either lighter or narrower. There may be times when display typematter is to be reproduced photographically where one can re-draw awkward characters.

Hyphens and dashes normally centre on the x-height of the lower case letters; if set with capitals, they must be cast higher on the body. The same suggestion should be applied to brackets [] and parentheses () which are designed for lower case and look sadly out of position with capitals.

In text setting, to relieve monotony, or to indicate a new train of thought, copy is set in paragraphs. The beginning of a new paragraph is usually indicated by an indentation of an em of the body size. Copy is usually set full out at the beginning of a chapter or under a sub-heading. Some printers and typographers prefer to set the first line of all paragraphs full out. In that case, to indicate the end of a paragraph insert a white line. The insertion of a thick lead makes backing up impossible.

Hyphens and parentheses, correctly cast for lower case (left) are too low for capitals (centre) so should be cast higher on the body of the type (right).

sea-green SEA-GREEN SEA-GREEN

(sea-green) (SEA-GREEN) (SEA-GREEN)

In display, quotation marks look better if thrown into the margin.

'I pray God,' said Lord Hawke, 'that no professional will ever captain England.' Poor Lord Hawke! A professional is captain

The Asian Wall Street Journal is **A WELCOME ADDITION...** to the Asian media scene. It's particularly appropriate not only for banking, financial and corporate campaigns but also for hotels, airlines, consumer durables, capital goods, car rental companies........ hitherto, there were no appropriate media in Asia for regional campaigns of this type.

The use for emphasis of question and exclamation marks from different founts can be very effective.

no time for false modesty

AS towchyng the comyng of our lord in our bodyly flessh, we may considre thre thynges of this comyng. That is to wete thoportunyte, the necessyte & the vtylyte ℂ The oportunyte of comyng is taken by the reson of the man that first was vanquysshyd in the lawe of nature of the default of the knowledge of god, by whiche he fyll in to euyll errours, & therfore he was constrayned to crye to god ℂ Illumina oculos meos, that is to saye, lord gyue lyght to myn eyen. After cam the lawe of god whiche hath gyuen commandement in which he hath ben overcome of Impuissance, as first he hath cryed ther is non that fulfilleth, but that comandeth. For ther he is only

The use of paragraph marks by William Morris, to save starting a paragraph on a new line.

Classical proportions for page margins from Jan Tschichold's *Designing Books*.

Another way to indicate the beginning of a new paragraph is to throw the first line out 12 points or so into the margin. This can be effective, and is used with some success in certain daily newspapers. The scribe's method of running copy on but dividing paragraphs with special paragraph marks is effective enough in black letter setting but I have rarely seen it done with any success for roman typefaces.

A break in copy that is more important than a paragraph break can be indicated by a row of asterisks or even a single asterisk.

NARROW MEASURES

Practically the only method of achieving even spacing in narrow columns of type of less than 36 characters is by free setting, that is with a straight left hand edge and a ragged right hand edge, as in typewriting. This is rather more difficult to set because the lines as far as possible should be broken as the sense dictates. For narrow measures always use a small setting. The wider the measure the larger the type.

In Linotype setting, the variable space bands range from extra-thin ($2-5\frac{1}{2}$ pts) to thin and thick, starting at $2\frac{1}{2}$ pts and 3 pts. Fixed spaces of $\frac{1}{2}$, 1 and 2 pts can be put in the line by hand; thin, en and em spaces by keyboard. The measure for Linotype setting is limited on most machines to 30 picas, though this can be extended to 36 ems. Intertype will set up to 42 ems. In slug-casting, the kerning characteristics of italics cannot be maintained, so this results in rather indifferent letter forms for these characters.

BOOK DESIGN AND PRODUCTION

From the time of the great fifteenth-century Venetian printers, the form, shape and margins of the book page have not altered much. At last there are signs of a little loosening up and the classical margins, agreeable though they are, are not the only margins one can usefully use in a book. For a book that is to be held in the hand and read, the classical margins still provide what is probably the best solution. For illustrated books, for books of instruction, and for books with tabular matter there are possible alternatives. Certainly for many reference books, an asymmetric page arrangement, with wide

margins appearing at the head or to the left (or right) of the type may be a more useful arrangement. And with typographic skill it need not look outlandish, though it may make backing-up impossible.

For traditional books (and traditional is not to be taken as a slighting term) printed by letterpress and to a lesser extent by offset on antique paper, which is a paper with a soft surface, 'old face' types are ideal, typefaces such as Bembo, Caslon, Garamond, Fournier. For smooth or art papers it is usually better to use a typeface with a greater inking surface, such as Baskerville, Plantin, Times New Roman, Ehrhardt, the Ionics and the Moderns, Walbaum, Caledonia and Bulmer, though Walbaum can look well on softer papers.

In book production, an important typographic factor is the set, or the relative width of the lower case alphabet. There are occasions when one wants to bulk out a book, and so uses a typeface with a wide set such as Baskerville, Imprint, Modern Extended, or Old Style. For narrow setting, Bembo, Fournier, Ehrhardt are all economical of space. Space saving can also be achieved by setting in a smaller size of a typeface with a large x-height such as Plantin Light, Times New Roman or Scotch Roman which are the optical equivalent, up to two sizes larger of a long ascender and descender typeface. (9 point Times visually equals 11 point Bembo). The use of grotesques for book work is increasing. They are best set in small sizes, in light weights and to narrow measures. They are not as flexible as letters with serifs, having no small capitals, and usually ill-favoured italics.

MAKE-UP OF A BOOK

In laying out a book there are certain conventions, such as the order for the preliminary pages. These conventions which Tschichold laid down in the Penguin rules (page 101) can be a useful guide, but I would not hesitate to break them. I would suggest that where possible the important items (contents, list of illustrations, preface and introduction) should be on right hand pages. Errata are usually printed on a separate slip and should be tipped-in opposite the first page of the text.

Another convention is the running headline. The usual practice is: title of book on left hand page, title of chapter or subject of page on right hand. Omit these in pocket

Printers' flowers used for a repeat pattern on a
book cover and jacket and for label on a binding,
(see opposite page).

size books or in books with many subheadings. They are
usually set in text size small capitals. Folios can be
incorporated in the running head, but do not use modern
style numerals with small capitals.

The typographer working on book production has two
other problems: the lettering on the case of a book and
the book jacket. The latter is a problem widely removed
from the text pages of a book. It is a graphic design
problem of marketing. There is no need to use the same
faces on the jacket, not even for the blurbs on the flaps
that turn over inside the book. In fact, if the text of the
book is printed on an antique paper and the jacket has
a smooth surface, it would be a mistake. For blurbs,
which are rarely more than 14 ems measure, use a
narrow set typeface, such as Ehrhardt or Times New
Roman and set it unjustified.

For the brasses of a book, use typefaces that are not
too heavy, that are without hairlines and, most import-
ant, that have large counters that will not fill in, such as
Plantin or Ionic.

THE USE OF PRINTERS' FLOWERS

There are still occasions when the designer can find a
use for fleurons and rules, either to provide a formal
framework for a title-page or for an advertisement or
to make up decorative repeat patterns for endpapers,
jackets or slipcases.

Another use is for framing stick-on labels. The fact
of such enclosure makes the typeface appear larger
than it would otherwise.

The gap between the design of books and the design
of periodicals has narrowed markedly in the last few
years. A typographer's job is, after all, communication
and if certain methods of layout help to put over ideas
more effectively than others, then they are just as valid
for books as they are for periodicals or advertising.
Advertising design in periodicals used to be more lively
than the editorial matter, both in copy and in presenta-
tion. Today the editorial layout is often more exciting.

Ninety per cent of a typographer's job in periodical
work is of course the layout and general presentation.
It is just another graphic design job. There are, however,
certain points that should be watched, including the
process by which the magazine is printed.

PROCESS

This conditions the choice of types for text-setting. For letterpress on coated papers use types with a good inking surface, such as Times New Roman. For stereo use medium weight types, without hair lines, such as Ionic or Imprint. For offset and photo-setting use lighter-weight types, (but avoiding hairlines), such as Baskerville or Apollo. For gravure, which mutilates and also thickens any typeface, use a light-weight face such as Old Style.

Type for half-tones: the procedure for this is the same for any process and merely means providing the block-maker or the reproduction studio with type pulls on Baryta paper, or on positive film indicating whether the type matter is to appear in black or in white (i.e. in reverse) in the dark areas of a half-tone. This is then put to camera and stripped into the negative (or positive) used for the plate.

THE DESIGN OF STATIONERY

Letterheads and billheads are often the first image a potential customer may receive from a company or a professional man. They are clearly of very great importance. The letterhead should not only be clear and readable, but should reflect something of the character of the sender. A jobbing printer who is expert at colour work needs a very different heading from one of the University Presses. This should be fairly obvious; I will not labour the point, except to say that a dogmatic design approach can produce very unsuitable results.

I doubt if there is any more justification for using an asymmetric layout than a symmetric one. Both can be effective. Dignity is certainly most easily achieved by symmetry; flexibility and informality by asymmetry.

Good quality paper, good design and good printing can be nullified by bad typing, so a designer ought to take into account the needs of the typist, with indications for margins, date lines, indents etc.

Good typing, like good typography, has to communicate simply and directly. The letterhead designer should make absolutely clear how the typist should place her copy. In fact when submitting designs for letterheads, it is a good idea to present some sheets with a letter typed as you would wish it to be.

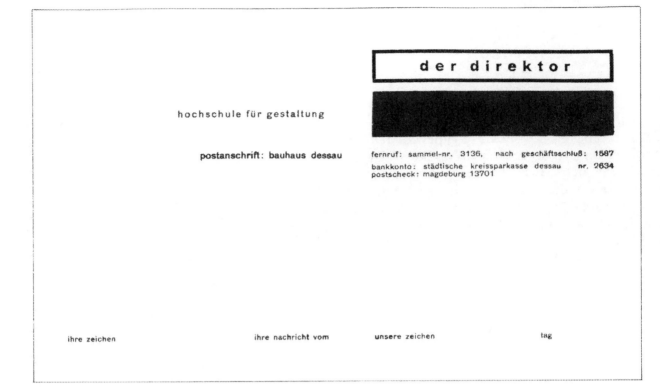

der direktor

hochschule für gestaltung

postanschrift: bauhaus dessau

fernruf: sammel-nr. 3136, nach geschäftsschluß: 1587
bankkonto: städtische kreissparkasse dessau nr. 2634
postscheck: magdeburg 13701

ihre zeichen ihre nachricht vom unsere zeichen tag

Letterhead for the Bauhaus, Dessau; set in Aurora
Grotesque and printed in black and red.

Letterhead produced as a specimen for Folio
Frotesque by the Bauer Typefoundry, Frankfurt-
am-Main.

Max Ebel & Sohn Baustoffhandel

Mainz-Weisenau

Fernruf Sammelnummer 43206
Telegramme ebelbau mainz
Lager: Mainz-Weisenau, Rheinstraße

Datum

RECHNUNG

Wir sandten Ihnen auf Ihre Rechnung und Gefahr

Letterhead designed for a theatre productions firm by Clarke/Clements/Hughes Limited 1975, using a playbill motif.

Letterhead showing the use of die-stamping, blind blocked for the word 'LONDON'. Award winning design for a British Stationery Council competition.

London Sawmills Limited

Tottenham Court Road London W 1
Telephone MUSeum 69896 Grams Saw London

The most useful size for business letters is A4 and for professional correspondence A5. Having said this there are still many people who prefer the old large post 'quarto' and 'octavo' sizes of 10in × 8in and 8in × 5in.

Having established the paper size or sizes, it is most important to scale your heading to the paper size. A setting that may look well on a quarto sheet may look over large on an octavo sheet, particularly if printed the narrow way of the sheet. (The long way is of course the same size as the width of the quarto sheet). There is much to be said for simplicity. It is possible to set the whole of a professional heading in one size. If emphasis is needed for any part, this can be set in the same size in a bolder face or in a different colour. There is no dogmatic reason for keeping to the same size. It does simplify setting but this point, I think, has been over-laboured by the purists. It is also in some ways easier and gives a more even tone. For many kinds of letter-heads, it may be necessary to make much more of the name block so, though the rest of the letterhead is set in one size, the company name could appear much larger, and possibly in a different colour.

Apart from these general observations on design, there is the all-important matter of detail, and minute detail at that. The care over detail is a typographic necessity in any printed work; in small jobs like letterheads it is of overwhelming importance. There is so little to see in a letterhead anyway, that everything should be exact and precise. A punctuation mark ill-placed can look disastrous . . .

In good text setting, unnecessary punctuation is omitted in order to help close, even setting. The same applies to letterheads. For instance, as in text setting, omit full points after Ltd, Mr, Mrs, Dr (for Doctor, but not after Dr. for Debtor as on a billhead).

In postal addresses omit full points after both letters and numerals (so WIR 4BP); letters representing degrees, decorations etc. can be set either with or without full points, thus: CBE, RDI or C.B.E., R.D.I. but M.A., D.Litt or D.LITT; where it is possible set in small capitals.

Omit commas after street or road numbers; 55 East 57th Street; and between city and postal districts: New York 22.

6. Rules are made to be broken

Before you start breaking rules, you should know what they are. Once you know the correct procedures you can look at them critically and see whether by deliberately flouting them you can add anything new to normal ways of communication. Certainly in advertising there is much to be said for unorthodox typography. A message has to be projected; anything that helps may be justified, even if it means using mixed-up founts, mutilating letters, using punctuation marks from larger or smaller founts, turning words upside down . . .

There is even a place for illegibility. Playing about with typefaces may result in a certain illegibility, but may also result in some visual excitement. All this has nothing, absolutely nothing to do with the production of books where, I am very sure, any interference between author and reader is quite wrong. In fact dullness is usually preferable to oddity. The book page is rarely a medium for self expression.

However eccentric the means he uses, the typographer is still only providing a medium of communication between an author and a reader, or a seller and a buyer. In the latter case it may be enough if the buyer only registers in his mind the name of the seller.

Media of communication outside printing may condition the reflexes of readers. TV screens and TV advertising have altered the appearance of much press advertising. Less and less is the ubiquitous man in the street inclined to read copy; he is conditioned to looking at pictures and to reading short, sharp, perhaps shocking, headlines.

The possibilities for experimental typography are considerable. When this kind of typography is handled by a poet, we come nearest to *my* understanding of what typography is all about, and that is not only the sense of words but also the look of the printed word on the page.

The Scottish poet, Ian Hamilton Finlay, has done some interesting experimental work in this vein. The pictorial aspect of his work is based on things seen. He wrote in a letter to me about the visual element in poetry: 'Typography in pure concrete poetry is always structural and not mimetic. It would be wrong to consider it as a thing apart from the poem, but if one did, one

Concrete Poetry. Typographic experiment by a student at the Canterbury College of Art.

'The Mouse's Tale' from *Alice in Wonderland* by Lewis Carroll. This suggests that there are endless possibilities for 'word pictures'.

Front and back cover of a catalogue for the Stedelijk Museum, Amsterdam, designed by W. J. H. B. Sandberg.
The 'a' is the common factor in the title '*acht argentijnse abstracten*'. The 'a' is printed in red on a brown pulp board cover.

```
         " Fury said to a
                mouse, That he
                met in the
              house,
         ' Let us
             both go to
               law : I will
                   prosecute
                      you.   Come,
                          I'll take no
                             denial ; We
                             must have a
                           trial : For
                        really this
                    morning I've
                  nothing
                to do.'
             Said the
               mouse to the
                  cur, ' Such
                     a trial,
                      dear Sir,
                           With
                         no jury
                       or judge,
                     would be
                 wasting
               our
                 breath.'
                   ' I'll be
                    judge, I'll
                      be jury,
                          Said
                      cunning
                    old Fury :
                 ' I'll
                  try the
                     whole
                      cause,
                        and
                      condemn
                     you
                    to
                   death "
```

would say it reinforces the sense of the structure, echoes repetitions etc.'

Today there are at least two kinds of poetry that make use of the form of the poem as a visual adjunct to the literary meaning. The first of these is 'concrete' poetry, which is closely related to the work of the Constructivists and is concerned with structure. The second is an off-shoot of Dada, and perhaps stems from the work of the French poet Apollinaire. Here, in the manner of Lewis Carroll's 'Tale of the Mouse', a poem about rain straggles down the page like little rain drops (see page 75).

Finlay goes on to say: 'In my opinion, the best concrete poetry always unites the visual with the semantic element; certain concrete poets though, have used words in a purely visual way.'

In his *Poster Poem*, the poet has parodied the old fashioned typographic circus poster. The imagery is doubled so that the fishing smack K47 is compared to a little circus pony and vice versa, for ponies and fishing smacks are fat, sturdy, and staunch. The coloured blinkers of the pony become the port and starboard navigation lights of the smack. The rainbow in its reflection in the sea is the hoop through which the pony jumps, or the boat sails. The corks, nets, etc are invoked in the manner of lesser circus turns. By implication the sea becomes the circus ring and so on.

One of the most successful experimental typographers is W.J.H.B. Sandberg, a former Director of the Stedelijk Museum in Amsterdam. Sandberg is an artist who has found one of his means of expression in typography. His catalogues for the Stedelijk Museum (over 300 since 1945) are a watershed in the world of art gallery productions. These catalogues are models of clarity, economically produced, often with re-pulped board covers, printed in black and one of the primary colours. In the example here the large letter 'A' is printed in vermilion on just such an 'oatmeal' surface cover board.

In the 1939–45 war, Sandberg played an important part in the Resistance. He was hiding from the Germans for two years, living precariously under a false identity. It was during this time that he started compiling his *experimenta typografica*.[11] His war experience heightened his faculties and gave him enough time to think.

acht
argentijnse
abstracten

11. *Sandberg* a documentary compiled by Ad Petersen and Pieter Brattinga. Kosmos, Amsterdam, 1975.

on the right, a red blinker

le circus!!

smack

K47

and crew

also

corks

nets

etc.

on the left, a green blinker

they

leap

BARE-BACK

through

the

rainbow's

(**hoop**)

Concrete Poetry: *Poster Poem* by Ian Hamilton
Finlay, printed by the Wild Hawthorn Press 1964.

Openings: openings and unfoldings of the new
poetry. Designed by Edward Wright. c. 1967.

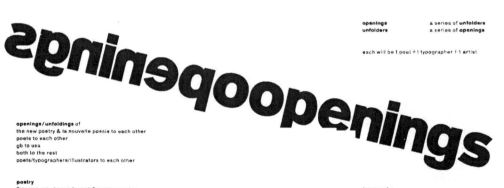

openings a series of **unfolders**
unfolders a series of **openings**

each will be 1 poet + 1 typographer + 1 artist

openings / unfoldings of
the new poetry & la nouvelle poesie to each other
poets to each other
gb to usa
both to the rest
poets/typographers/illustrators to each other

poetry
2-ness everywhere inherent; & poetry, creative
communication, removing from the i-full
im-/ex- pressionist mercifully developed each
apart over the last 10-15 years

content - in america from 1950 the new poetry
springing w/ maximus & olson's gloucester
to not the objective but the objected - where
stance to reality can be stance to poem, its
energy spoken - its freshness of **words** & more
than words

form - & otherwhere la nouvelle poesie ; from 1955
in switzerland iceland & brazil - concrete
w/ gomringer rot & the noigandres turning the
syllable solid - its energy (verbico visual or visual)
seen - its freshness **words** painterly - in france
from 1955 audiopoems of chopin gysin heidsieck -
semantic or abstract - energy as heard - its
freshness - **words** musicianly

1964 these two - the projective & eyear - open to
each other

typography
openings are constituted by
 poet/typographer/artist
openings are active poetry
openings make everybody make poetry

poetry means making
 poesis

a typographer thinks that
the poem is the first of the first things first

graphics
we aim to produce a series which is a complete
integration of graphics and text, i e **not** an
illustrated poem or a captioned drawing but a
p o e m in fact, we always
i start out with, and
c work from, the poem
t the difficulty lies in
u maintaining the
r balance between
e text and drawing

net/net: concrete poem by Ian Hamilton Finlay. The interwoven closely set words and letters and the alternating colours have the appearance of an actual fishing net. 1968.

netnetnetne
netnetnetne
netnetnetnet
netnetnetnet
netnetnetne
netnetnetne
netnetnetne
netnetnetne
netnetnetne
et cet era

Page from *Typographic Variations on the Poem Autobiography by Louis Macneice*. Designed as a typographic exercise by the students of the Plymouth College of Art.

come back early or never come

My father made the walls resound

He wore his collar dnuor yaw gnorw eht

PETER MAYER:

A million dollars of expletives encapsulated in epithets.

Type in Art. *That Extra Month* and *Ask anyone who has been there*. Designed and printed by Robert Brazil. 1972.

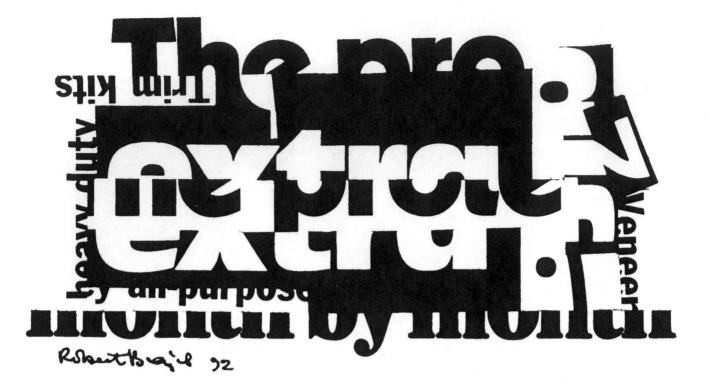

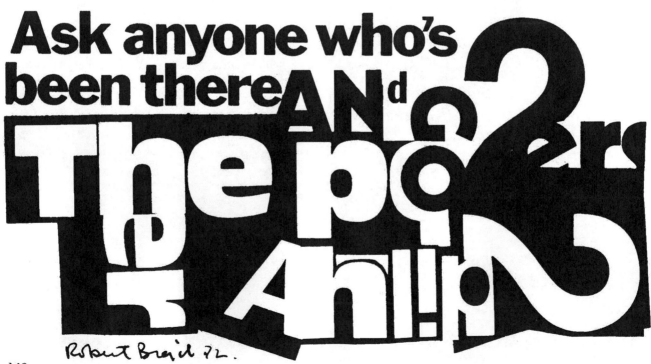

'The usefulness of jugs' from *Experimenta Typographica II* by W.J.H.B.Sandberg. *Verlag Galerie der Spiegel, Cologne.*

Of the two examples by Sandberg from *experimenta typografica 11* shown here, 'The usefulness of jugs' is a play on the sense of the word 'kruges' (jugs), where the letter 'U' in the middle of 'kruges' takes the form of a pitcher filled with water. It is a kind of rebus. In the second example, 'The inner life principle', the word 'life', set in Clarendon capital letters is made legible by printing the spaces around and inside the letters.

In 1963 the Stedelijk Museum and the Staatliche Kunsthalle at Baden-Baden mounted an exhibition on the theme of 'Art and Writing'. This loose description covered experimental and mimetic typography, word pictures, collages and much else that I have touched on here. The catalogue[12] of this exhibition is still a highly stimulating document, showing as it does the work of artists as diverse as Kasimir Malevich and Robert Rauschenberg, or of typographers as different as Apollinaire and Marinetti.

Mimetic typography can be most telling, though it is no new thing. In *Alice in Wonderland* Lewis Carroll made use of it when the Mouse said to Alice: 'Mine is a long and sad tale!' Laurence Sterne, a hundred years earlier, in *Tristram Shandy*, in describing a tricky stage of Uncle Toby's courtship of the Widow Wadman, leaves two quite blank pages for Chapters 297 and 298. Nothing could better express the emptiness of Uncle Toby's mind at that particular moment.

The ramifications of typography are wide. By such experiments as that opposite, Robert Brazil shows how a typographer can free himself from the restrictions of literary sense and so develop an intuitive ability to design the printed page. His successful practice depends on so many things; it depends on an understanding of the meaning of words, on a knowledge of printing processes, and on a meticulous attention to detail. I think also, that it depends on the typographer being a cultured man, that is, someone who is conscious of both the past and the present in the arts, in literature and in the crafts of printing and typography. This knowledge is not mere scholarly pedantry, but something that makes one alive to the fact that typographic design is as fluid as our language and as changing as modern life.

'The Inner Life principle' from *Experimenta Typographica II* by Sandberg. *Verlag Galerie der Spiegel, Cologne.*

12. *Schrift und Bild* Dietrich Mahlow *et alia*. Typos Verlag, Frankfurt am Main, 1963

A glossary of terms used in this book

	
'A' Series	one of the ISO series of sizes for unprinted paper and printed leaflets, booklets etc, each being half the size of the next. Thus A0 paper is 841 × 1189mm, and the most used, A4 is 210 × 297mm; A5 is 148 × 210mm.
Ampersand	contraction of 'and' = &.
Antique paper	good quality paper with a rough surface.
Art paper	clay-coated paper with a shiny surface.
Ascender	the part of the letter that is above the x-height.
Backing up	printing the reverse of a sheet with the lines exactly lining up with those on the other side.
Bank paper	thin, tough almost transparent paper suitable for layouts.
Baryta paper	a coated paper suitable for reproduction proofs.
Beard	the metal sloping away from the face of a letter, at head or foot.
Bleed	when the edges of a printed page are trimmed so as to cut into the printing of a block at edge, it bleeds off.
Body	the solid shank of the letter of a cast metal type.
Body line	the line at the foot of a lower case letter x.
Bolts	the folded edges of the printed sheet at head, tail and fore-edge before trimming.
Brasses	a deeply cut brass block, used for blocking on bindings.
Broadsheet	large sheet of paper usually printed on one side only.
Casting off	assessing the length of a manuscript to estimate the number of pages of a given size of type.
Cross head	is a subordinate centred heading.
Descender	the part of the type below the x-height, g,y, etc.
Die stamping	is printing when incisions into a metal plate are inked and paper forced against it so that the inks comes off onto it. It is often called 'intaglio'.
Drawn-on	covers on paperbacks.
Em	is the square of the body of a piece of type (i.e., the space of a capital M.)
En	is half the width of an em; it is about the average width of all letters and spaces.
Folio	page number.
Full point	printers' term for full stop.
Galley trays	hold composed type not made into pages – hence 'galley proofs'.
Gravure	a method of intaglio printing from flat or rotary plates.
Half-tone	printing plate of copper or zinc, photographically produced; or screened toned reproduction for offset or gravure printing.
Hot metal	letterpress as opposed to filmsetting.

Imposition	the arrangement of pages in position for printing, governing the correct sequence when folded.
Insert	sheet or part of a sheet placed inside another sheet after folding.
International ISO sizes	paper sizes.
Justified setting	the equal and exact spacing of letters and words to a given measure.
Leading	strips of lead less than type height, used for spacing out lines of type.
Letterpress	printing from raised blocks or type.
Ligature	tied letters such as ffi, ffl, cast on one body.
Lining numerals	numerals all the same height as the capital letters.
Literal	a misprint.
l.c.	lower case or small letters.
Modern face	typefaces designed at the end of the eighteenth century, on geometrical principles. Its distinguishing features are vertical stress of weight and hair line serifs.
Offset printing	printing from a lithographic stone or plate transferred by a rubber roller to the paper.
Old face	of typefaces, are those modelled on 15th century to 18th century designs.
Old style numerals	numerals with ascenders and descenders as opposed to 'modern' numerals that line up with the capital letters.
Over running	is taking words back or forward from one line to another.
Pica Em	approximately 1/6th of an inch, a twelve point em (American point system).
Point	1/12th of a pica and so there are about 72 to an inch.
Quadrat	piece of blank metal an em space wide and less than type height used to fill spaces and short lines in a page.
Recto	is a right hand page.
Run on	a sentence continued in the same line as the previous one, not a distinct paragraph. Chapters starting below the previous one on the same page are said to run on.
Running head	the heading at the top of a page.
Stereo	a replica from type or block cast in metal from a papier mâché mould.
Sidehead	is a small subheading with type running on after it.
Slug	is a line of type cast in one piece.
Stone	the large table in a composing room where formes of type are assembled within the chase.
Substance	of paper is expressed in grammes per square metre (g/m^2).

Tip-in	an illustration or other loose plate pasted in to a book at its back margin.
U.C.	upper case or capital letters.
Verso	is a left hand page.
White line	the space exactly the depth of a line of type, put between lines, to make a space that will not interfere with exact backing up.
Widow	a single word turned over at the end of a paragraph or at the foot of a page.
Wrap-round	pages of illustrations wrapped round a section, or part of a section, in the make-up of a book.

A SHORT COMPUTER PHOTOSETTING GLOSSARY

Algorithm	a sequence of logical steps in programming to achieve a predictable result; computer photosetters have one, e.g., for line ends, involving unit counting, division, testing of word breaks, re-spacing, etc.
Base alignment	when the bottoms of letters of different sizes are composed level, so one can easily mix type sizes in the same line. Lead type doesn't align; photosetting by VIP does.
Bit	is short for 'binary information transfer'; it is the basic unit of information in computer typesetting, where it usually takes the form of one 'hole-or-no-hole' in paper tape.
Byte	a string of bits used together in combination to denote one of a number of symbols, each called a character.
Format storage	the ability of a computer to store a sequence of commands, e.g., to lead, repeat a word, change type size; so that the sequence may be called up and used with one keystroke only.
K	roughly 1000, more accurately 1024 (the nearest binary equivalent) and the normal index of computing storage ability. So the VIP's 12K × 16-bit memory is 196608 bits.
Parameters	the rules or specifications or numerical values, stipulated in advance by the operator, to govern computer decisions or actions; e.g., in typesetting, the number of units for minimum or maximum word space.
Pi characters	one not in a normal fount of type or photosetter master, e.g., special signs or symbols.
TTS	TeleTypeSetter. Most computer photosetters use TTS coding on paper tape.
VDU	Visual Display Unit; also called VET, Visual Editing Terminal.

Printed in the United States
137516LV00001B/97/A